010101:

ART IN TECHNOLOGICAL TIMES

SAN FRANCISCO
MUSEUM OF
MODERN ART

This catalogue is published on the occasion of the exhibition
010101: Art in Technological Times, organized by the San Francisco
Museum of Modern Art and on view March 3 to July 8, 2001.

Presented by Intel Corporation.

The exhibition is made possible by Collectors Forum, an auxiliary of the Museum.
Airline transportation generously provided by American Airlines. Additional support provided by The Consulate
General of Switzerland and The Consul General of Switzerland Roland Quillet, with the participation of
Presence Suisse a l'Etranger.

LIBRARY OF CONGRESS CATALOGING-IN-PUBLICATION DATA:

010101 : art in technological times.
 p. cm.
 Includes bibliographical references.
 ISBN 0-918471-63-X (pbk. : alk. paper)
 1. Art and technology—Exhibitions. 2. Multimedia
(Art)—Exhibitions. I. San Francisco Museum of
Modern Art.

 N72.T4 A123 2001
 709'.04'0707474761—dc21
 00-067029

DIRECTOR OF PUBLICATIONS AND GRAPHIC DESIGN: Kara Kirk
MANAGING EDITOR: Chad Coerver
ART DIRECTOR: Keiko Hayashi
EDITOR: Karen Jacobson
DESIGNER: Gail Swanlund
PUBLICATIONS COORDINATOR: Alexandra Chappell
PUBLICATIONS ASSISTANT: Jason Goldman
RESEARCHER: Julia Bryan-Wilson
PRINTING: Celeste McMullin, the Printcess;
Hemlock Printers

Printed and bound in Canada.

PHOTOGRAPHY CREDITS:
Unless otherwise indicated below, all images are
courtesy of the artist.

P. 6: courtesy Luhring Augustine, New York: p. 29:
courtesy Angles Gallery, Santa Monica, California;
p. 31: photos by Ian Reeves; p. 33: courtesy of the
artist and Galerie Barbara Weiss, Berlin; p. 37,
background: courtesy Country Life Picture Library;
p. 51: photo by Ian Reeves; p. 53: photo by Richard
A. Stoner, courtesy Carnegie Museum of Art,
Pittsburgh; p. 63, top right: photo by Jacques
Dufresne; p. 63, middle left: photo by Patrick Moine;
pp. 63 (bottom), 64–65: courtesy of the artist and
Softimage, inc., Montreal; p. 79: photo by Ron
Gordon, courtesy Donald Young Gallery, Chicago;
p. 81: courtesy Matthew Marks Gallery, New York;
p. 97: courtesy Kukje Gallery, Seoul; p. 99: courtesy
of the artist and Jack Hanley Gallery, San Francisco;
p. 105: courtesy Luhring Augustine, New York; p. 117:
courtesy James Cohan Gallery, New York; p. 123:
courtesy Shoshana Wayne Gallery, Santa Monica,
California; pp. 129, 131: courtesy of the artist and
D'Amelio Terras Gallery, New York; p. 133: photos by
Frank Oudeman and Sarah Sze, courtesy Marianne
Boesky Gallery, New York; p. 137: courtesy Shoshana
Wayne Gallery, Santa Monica, California.

AUTHORSHIP OF THE INDIVIDUAL ARTIST ENTRIES IS
INDICATED AS FOLLOWS:
AB: Aaron Betsky; JB: Janet Bishop; KF: Kathleen
Forde; AG: Adrienne Gagnon; JW: John S. Weber; and
BW: Benjamin Weil.

ILLUSTRATION ON P. 6:
Tatsuo Miyajima, *Floating Time,* 2000, installation view

010101:

CONTENTS

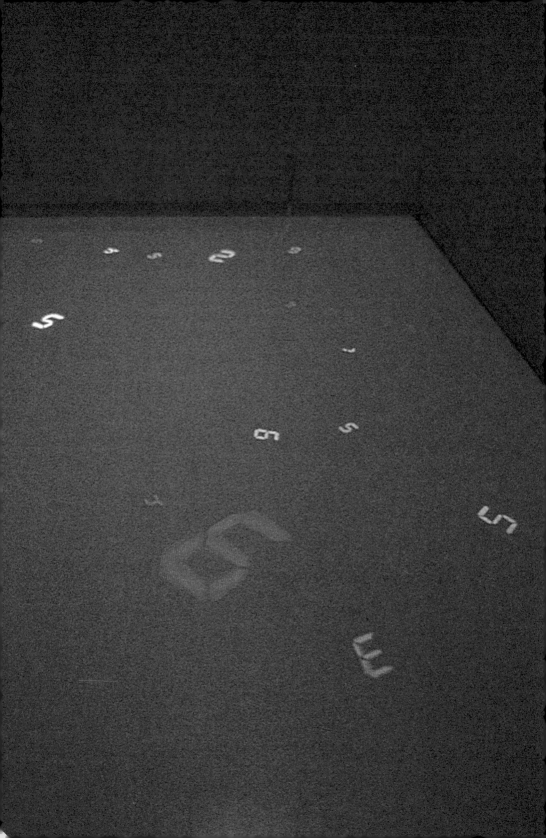

Intel Corporation is proud to present *010101: Art in Technological Times*, a groundbreaking exhibition organized by the San Francisco Museum of Modern Art to explore the confluence of art and technology in the digital age. The artworks included in this exhibition—from the more traditional arts of painting and sculpture to sound art and immersive virtual environments—demonstrate that technology is enabling a whole new range of expression for artists working in all media.

The show is more than an art exhibition, however; it is also a look at how technology is bringing new ideas and working processes to the studio and stimulating new exhibition practices at museums. Computers and the Internet allow artists to connect with their potential audiences in new ways, thus providing them with a powerful means to explore and share cultural values while helping to realize the educational possibilities of the Internet.

These pioneering artists are demonstrating that digital technology, like photography and video before it, offers a new and vital means of creative expression and communication.

Pam Pollace
Vice President of Corporate Marketing
Intel Corporation

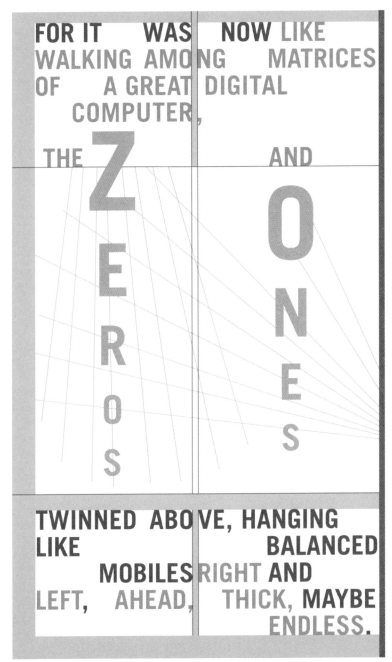

FOR IT WAS NOW LIKE WALKING AMONG MATRICES OF A GREAT DIGITAL COMPUTER, THE ZEROS AND ONES TWINNED ABOVE, HANGING LIKE BALANCED MOBILES RIGHT AND LEFT, AHEAD, THICK, MAYBE ENDLESS.

For it was now like walking among matrices of a great digital computer, the zeros and ones twinned above, hanging like balanced mobiles right and left, ahead, thick, maybe endless. **THOMAS PYNCHON, 1966**

FOREWORD AND ACKNOWLEDGMENTS

DAVID A. ROSS
DIRECTOR

AS WE SLIP PAST THE BORDER DELINEATING THE END OF THE AGE of mechanical reproduction and find ourselves in a new territory, we sense that things have changed in ways we cannot fully express. For one thing, we are still quite unsure of the nature of this new space we inhabit. It's not that we aren't trying, or that there are insufficient clues to the nature of the era in which we find ourselves. For the past decade, poets, pundits, and academics alike have been trying with only limited success to name or describe this new thing.

Some thinkers focus on cybernetic space itself, applying the concepts associated with that term to the social order it seems embedded within. But Norbert Wiener, the mathematician who coined the term *cybernetics* in the late 1940s, was profoundly accurate in his definition of it as a field for the study

of control and communication systems in the animal and the machine, and, by extension, the relationship between the two. It seems that Wiener was, understandably, describing his worldview from the machine-age side of the boundary. And though the issue of control remains a grave concern (especially when carried to Orwellian social conclusions), it is not necessarily the defining aspect of this new era we know we are already deeply within.

Others feel that the essential idea defining this moment is that things have shifted from the analog to the digital. This too represents a profound shift in the ways things work, as what we term "digital" forms the basis of most of the new technologies that have so transformed our day-to-day lives. Though there is something deeply disturbing about the loss of the world of analog logic—the gray scale connecting black to white, the subtle nuances of older technologies that were not inherently and essentially precise—there is also something oddly liberating about a world of ones and zeros. And though I won't argue with the idea that we are quickly becoming digital as the biotechnologies and interrelated digital nanotechnologies continue to erase the line between machine and animal, I'm still not convinced that the notion of digital is sufficient to define or even describe our times.

The exhibition *010101: Art in Technological Times* sets out to describe this moment from the most evocative yet perhaps the least precise perspective imaginable. It is our hope (and assumption) that we can learn a great deal about this moment not by arguing over its defining terminology or the subheading that historians will use to refer to it, but by looking closely at and thinking carefully about the work of contemporary artists. This time-honored approach to our search for the zeitgeist follows the logic of the Korean artist Nam June Paik, who prophetically noted in the mid-1970s that what was called for was not cybernetic art, but rather art for cybernetic times.

Accordingly, the exhibition consists of work that is directly engaged in the use of new digital technologies as well as works of art made with more traditional technologies. Interestingly, the curatorial team that organized this exhibition decided early on that the impact of technologies upon the way we conceive of artistic expression should be at least as interesting as the new products emerging from advances in manufacturing and communications technologies. Following that

decision, the *010101* curators expressed an interest in mapping the onto-logical shifts, the changes in social relationships, the evolution of trans-formed aesthetic practices and new narrative forms, the expression of our collective unease, and not least, the ways that our essentially human need for beauty has infiltrated this world of ones and zeros.

This exhibition is, as I have mentioned, a collaborative under-taking among nearly the entire curatorial staff. On this level alone, it represents one way in which art museums can think outside of the often overly prescriptive medium-defined categories that have for too long restricted how contemporary art functions as a site for the contest of values and ideas. Though I am deeply grateful to all of the participating curators for their willingness to work together in this fashion in pursuit of a very elusive goal, each curator should be noted individually for his or her contribution to the effort: Aaron Betsky, curator of architecture, design, and digital projects; Janet Bishop, curator of painting and sculpture; Kathleen Forde, curatorial associate for media arts; John S. Weber, the Leanne and George Roberts curator of education and public programs; and Benjamin Weil, curator of media arts. Adrienne Gagnon, former curatorial as-sociate for painting and sculpture, also served as a curator for this project before her departure in late 2000. Thanks are also due to Lori Fogarty, former senior deputy director, and to the team of Ruth Berson, director of exhibitions, and Jennifer Siekert, project coordi-nator, who undertook the daunting challenge of coordinating this complex interdepartmental project—a duty they performed with grace and good humor. This provocative and insightful exhibition is the product of the entire group's spirited and creative approach, as well as their boundless energy and enthusiasm.

This exhibition is the first in the Museum's history to combine commissioned work available only on the Internet with works dis-played solely within the traditional space bound by the Museum's walls. In doing this, we recognize that there are at least two very distinct kinds of exhibition space available to artists today and that, while we recognize and respect their differences, clearly they can be deployed in parallel in the service of a single project. But this is only the most visi-ble manifestation of how the production of *010101* engaged the new technologies structurally as well as thematically.

In thinking through the ways in which the Internet has changed our relationship to more traditional forms of publishing and exhibition design, the curators, the Museum's publications and graphic design department, and the designers working on the project wrestled with the ways in which an appropriate balance between the in-building, online, and in-print components of the exhibition could most effectively work together in the service of our visiting public. This innovative and insightful publication is the product of the efforts of Chad Coerver, managing editor; Karen Jacobson, editor; and Gail Swanlund, catalogue designer. They were assisted by Alexandra Chappell, publications coordinator, and Jason Goldman, publications assistant. The extensive Web site was produced by Sherry Miller, director of Web content for 010101, and Julie Kim, acting Web manager, while the design of the site was carried out by Stephen Jaycox, Anthony Amidei, and Steve Barretto of Perimetre-Flux, the firm that also designed the exhibition galleries. Keiko Hayashi oversaw the visual integration of the Web site, publication, and exhibition designs in her role as art director. All of these individuals worked together for nearly two years in the preparation of this project, and on behalf of the Museum's Trustees I thank them all for a remarkable job.

SFMOMA is fortunate that support for this exhibition came in the form of a multifaceted partnership with Intel, a corporation devoted to innovation and the idea of innovation. Our collaboration with Artmuseum.net, the pioneering online visual arts service produced by Intel, has been invaluable. Support from Intel was not merely financial but also took the form of deeply appreciated technical advice from Kevin Teixeira, Dana Houghton, and Vince Thomas. Finally, I would like to personally express my gratitude to Intel Chairman Andrew Grove for his continuing interest in SFMOMA and particularly for his support of this project.

The exhibition is also made possible by Collectors Forum, an auxiliary of the Museum, and airline transportation has been generously provided by American Airlines.

At SFMOMA, there are many staff members who contributed particular care and attention to this exhibition, but I would like to recognize the following persons in particular: Susan Bartlett, associate registrar, exhibitions; Matthew Biederman, exhibitions technical

manager; Lorna Campbell, assistant registrar; Paula DeCristofaro, paintings conservator; Alina Del Pino, museum preparator; Steve Dye, exhibitions technical assistant; Evan Forfar, chief preparator; Barbara Levine, former exhibitions director; Lani Proctor, associate director of development, corporate partnerships; Kent Roberts, installation design manager; Rico Solinas, museum preparator; Jill Sterrett, head of conservation; Sarah Tappen, senior associate registrar, permanent collections; and Marcelene Trujillo, assistant exhibitions director.

Of course, such an undertaking could not have been achieved without the generous participation of the lenders, who not only contributed artworks to this exhibition but also provided the Museum with research materials and photography. We are enormously grateful to ACME, Los Angeles; Angles Gallery, Santa Monica, California; Marianne Boesky Gallery, New York; Rena Bransten Gallery, San Francisco; James Cohan Gallery, New York; D'Amelio Terras Gallery, New York; Doug Hall and Diane Anderson Hall; Institut für Auslandsbeziehungen, Stuttgart/Berlin; Jack Hanley Gallery, San Francisco; Kukje Gallery, Seoul; Luhring Augustine, New York; Matthew Marks Gallery, New York; Mobile Home Gallery, London; Mondstudio, Frankfurt; Andrea Rosen Gallery, New York; Shoshana Wayne Gallery, Santa Monica, California; Taipei Fine Arts Museum; Chris Vroom, courtesy Feigen Contemporary, New York; Galerie Barbara Weiss, Berlin; Pat and Bill Wilson; Donald Young Gallery, Chicago; and other private collections.

Finally, we are most indebted to the artists in the exhibition, many of whom have traveled great distances and provided invaluable assistance in order to make the presentation of their works possible. It is their creative risk taking that has challenged us to come to a deeper understanding of the ways in which new technologies have impacted our daily lives and forever altered the cultural landscape.

END

RADIOS?

FINE.

SYPHILIS?
IF YOU LIKE.

PHOTOGRAPHY?
I DON'T SEE ANY REASON WHY NOT.

THE CINEMA?
THREE CHEERS FOR THE DARKENED ROOMS.

WAR?
GAVE US A GOOD LAUGH.

THE TELEPHONE?
HELLO.

YOUTH?
CHARMING WHITE HAIR.

TRY TO MAKE ME SAY THANK YOU:
"THANK YOU."

THANK YOU.

IF THE COMMON MAN HAS A HIGH OPINION OF THINGS WHICH PROPERLY SPEAKING BELONG TO THE REALM OF THE LABORATORY, IT IS BECAUSE SUCH RESEARCH HAS RESULTED IN THE MANUFACTURE OF A MACHINE OR THE DISCOVERY OF SOME SERUM WHICH THE MAN IN THE STREET VIEWS AS AFFECTING HIM DIRECTLY.

Radios? Fine. Syphilis? If you like. Photography? I don't see any reason why not. The cinema? Three cheers for the darkened rooms. War? Gave us a good laugh. The telephone? Hello. Youth? Charming white hair. Try to make me say thank you: "thank you." Thank you. If the common man has a high opinion of things which properly speaking belong to the realm of the laboratory, it is because such research has resulted in the manufacture of a machine or the discovery of some serum which the man in the street views as affecting him directly. **ANDRÉ BRETON, 1924**

BEYOND THE SATURATION POINT: THE ZEITGEIST IN THE MACHINE

JOHN S. WEBER

OVER THE PAST DECADE THE WORLD OF CONTEM-
PORARY ART has experienced the beginnings of a
tectonic shift. Its contours have been increasingly
visible in major international art shows of the past
five years. Whereas ten years ago exhibitions such as
New York's Whitney Biennial, the Venice Biennale,
or Documenta in Kassel, Germany, included just a
few major video installations, in 1997 and 1999 the
use of video became commonplace. Banks of moni-
tors, projected video images filling entire walls, and
tiny video screens were a regular, even predictable
presence, employed by artists who might or might
not even consider themselves "video artists." *010101:
Art in Technological Times* charts that trend in installa-
tions, in single-monitor works, and in digital works
that employ video projection. But the dramatic
emergence of video technologies as a mainstream
art medium is only one byproduct of a more en-
compassing shift in contemporary culture. E-mail;

cell phones; DVD movies; CD audio disks; MP3 files; desktop, laptop, and palmtop computers; the World Wide Web; digital cameras; and video camcorders—communication, by image or word, occurs more and more along networked digital pathways, via digital devices aggressively marketed by a global economy. Like it or not, high tech has arrived as a component of everyday life, and artists are adopting it in the studio, deploying it in the gallery, inhabiting it on the Internet, and making work that reflects its presence in society today in a stunning range of ways. This situation is the subject of *010101*.

The increasing use of video by artists—although just a single indicator of a larger shift—is a case in point. Over the past ten years the downward-spiraling cost of computers, digital camcorders, and software-editing tools that can pump video directly into a desktop computer brought video production within the grasp of virtually any artist who wanted to do it. The results are now visible in galleries around the world. In essence, video stopped being "video art" and is now just art—another acceptable means to say what the artist wants to say. The video camera became a tool, not a crusade or an artistic calling, and video installations started showing up in galleries formerly devoted to painting and sculpture. The same thing happened to photography in the late 1980s, and it will, in all likelihood, happen to what we might think of as "computer art" over the next few years. Digital technologies have arrived as part of the basic tool set, and they aren't going away.

It's worth emphasizing here that the infusion of technology-based artworks into the art arena, and the background effect of technology on traditional art practice, hasn't produced a new "style" or "movement" and that these works do not constitute a single medium or mode of art making. Rather, they open a field of possibilities that artists are exploring on all scales, from the production of individual objects to extensive cycles of works, installations, and multiyear projects. The variety of work on view in *010101* reflects this fact. Although it represents only a fraction of a much larger outpouring of technology-related art, the exhibition encompasses a range of video practices, sculpture, design projects, computer-driven installations, traditional drawings and paintings, new artworks commissioned on the Internet and for the gallery, and a Web site for dialogue, public programs, and background information on the show. *010101* is an exploration of a transitional moment in art and exhibition

Video is the latest step in a process that is destroying the spectator ritual in art—the going out to the temple to see it—but by no means the last. The next step is to get rid of the intervening structure, the cameras, the monitors, and telecasting circuitry . . . so that I can transmit to and receive from your mind instantly, without the need for the tape or the camera. **DOUGLAS DAVIS, 1976**

making, and as such, it has deliberately avoided seeking stylistic consistency. Both in format and in terms of the art presented, the exhibition offers deliberate and dramatic contrasts in the use of technology and attitudes toward it.

What this can mean in artistic terms is clear in works as varied as those of Char Davies, Craig Kalpakjian, and Janet Cardiff. All of these pieces use digitized moving imagery to play with perception, but in radically different ways. Davies and Kalpakjian create an illusion of reality from digital scratch—that is, computer graphics—while Cardiff uses a digital camcorder and audio deck to shoot and record "real" sites and sounds. Kalpakjian's *Corridor* (1995; pp. 94-95) leads us on an infinite, unvarying journey through a photorealistically bland office corridor created entirely on the computer and output to a monitor as a digital movie. Other than the fact that it never stops and never changes, the movie might be showing a real hospital corridor or a hallway from one of the cookie-cutter corporate office towers dotting the Silicon Valley landscape. It possesses just that kind of creepy, squeaky-clean eeriness and plausibility.

In contrast, Davies's *Ephémère* (1998; pp. 62-65) is a phantasmagoric abstract landscape, presented in the form of an immersive, three-dimensional, virtual-reality environment. The user or participant (*viewer* would be too passive in this case) navigates through it actively, and no two journeys will ever be identical since the experience is a synthesis of the participant's decisions and the computer's response to them. Davies's world has a distinct look and feel, and the roughly fifteen-minute trip moves along a more or less programmed trajectory. But the specific form it takes is like any journey across a complex landscape: precisely what the traveler sees and feels will depend on complex variables that are impossible to fully predict or reproduce.

Cardiff's video walk offers another set of revealing contrasts (pp. 52-53). Unlike Kalpakjian or Davies, she starts with "real" images—video shot mostly in the Museum itself, with a voiceover and soundtrack that blend scripted narrative by the artist, ambient sounds recorded onsite, and audio collage from a variety of other sources. Visitors can check out a small digital video camcorder with high-quality headphones and retrace Cardiff's steps through the Museum by following her directions on the soundtrack and the image itself, moving from gallery to gallery and space

to space. The effect is similar to being inside the artist's head but looking out at the real world as she sees it, as if in a reverie she's experiencing. Like Davies's invented world, it's totally engrossing. But whereas Davies and Kalpakjian make fiction feel like reality, Cardiff rewrites real experience—both her own and the viewer-participant's—as fiction.

None of this work could be made without the computing power, comparative economy, and availability of today's digital editing, design, and display tools, and the art on view throughout *010101* demonstrates the direct and indirect impact that the electronics and software industries have had on art making. Relatively affordable video projection systems allow artists such as Heike Baranowsky to take a single video stream, copy it four times, and flip it twice, projecting the result as a mesmerizing, kaleidoscopic trip around Paris in her installation *AUTO SCOPE* (1996–97; pp. 32–35). Digital video editing allows Euan Macdonald to show two jet planes flying side-by-side, seemingly mating in the sky (pp. 98–99). Jeremy Blake uses the same basic tools to create a unique blend of video, scavenged film clips, computer design, and sound in his work (pp. 46–49), something like a real-time cross between Mondrian, B movies, and *Star Trek*. Other artists—such as Lee Bul, Karim Rashid, and Shirley Tse—take advantage of the products and capacities of the plastics, industrial design, and packaging industries as a starting point for sculpture and installations unimaginable in pretechnological times (pp. 96–97, 118–19, 136–37).

In some cases, the artists in *010101* still work with traditional media, notably painters such as Kevin Appel, Chris Finley, and Adam Ross (pp. 28–29, 76–77, 122–23). Here, high-craft painting displays visual effects, geometries, distortions, and translucency in ways more commonly seen on a computer screen, yet the work is 100 percent hand-made. They watch as the computer proliferates new ways to visualize space and form, then register their fascination in pigment rather than pixels. This may be painting in technological times, but a close look at the lapidary, pristine surfaces achieved by Appel and Ross leaves no doubt about the depth of their commitment to the medium and their understanding of its demands and joys. They are painters, unapologetically and unambiguously.

In contrast, artists such as Karin Sander, Roxy Paine, and Jochem Hendricks employ new technologies when it suits them, without

The whole of life of those societies in which modern conditions of production prevail presents itself as an immense accumulation of spectacles. All that was once directly lived has become mere representation. **GUY DEBORD, 1967**

What was truth for the painters of yesterday is but a falsehood today. . . . Who can still believe in the opacity of bodies, since our sharpened and multiplied sensitiveness has already penetrated the obscure manifestations of the medium? Why should we forget in our creations the doubled power of our sight, capable of giving us results analogous to those of the X-rays? **UMBERTO BOCCIONI ET AL., 1910**

you break the bounds of your bag of skin in this way, you will also begin to blend into the architecture. In other words, some of your electronic organs may be built into your surroundings. There is no great difference, after all, between a laptop computer and a desktop model, between a wristwatch and a clock on the wall, or between a hearing aid fitted into your ear and a special public telephone for the hard-of-hearing

in its little booth. It is just a matter of what the organ is physically attached to, and that is of little importance in a wireless world where every electronic device has some built-in computation and telecommunications capacity. So "inhabitation" will take on a new meaning—one that has less to do with parking your bones in architecturally defined space and more with connecting your nervous system to nearby electronic organs.

Once you break the bounds of your bag of skin in this way, you will also begin to blend into the architecture. In other words, some of your electronic organs may be built into your surroundings. There is no great difference, after all, between a laptop computer and a desktop model, between a wristwatch and a clock on the wall, or between a hearing aid fitted into your ear and a special public telephone for the hard-of-hearing in its little booth. It is just a matter of what the organ is physically attached to, and that is of little importance in

YOUR ROOM AND YOUR HOME WILL BECOME PART OF YOU, AND YOU WILL BECOME PART OF THEM.

a wireless world where every electronic device has some built-in computation and telecommunications capacity. So "inhabitation" will take on a new meaning—one that has less to do with parking your bones in architecturally defined space and more with connecting your nervous system to nearby electronic organs. Your room and your home will become part of you, and you will become part of them. **WILLIAM J. MITCHELL, 1995**

grounding their careers in a single artistic medium or direction. Sander and Hendricks have both employed high-end scanning and output technologies to create work deliberately untouched by their own hands, while Paine rigged an inexpensive laptop computer to drive an automated, assembly-line sculpture-making machine. His 2001 *SCUMAK no. 2* (newspeak for "sculpture maker") cranks out one colorful, abstract blob sculpture after another by dripping molten plastic goo onto a conveyor belt in a slow, carefully programmed manner (pp. 116–17). The pieces, roughly twenty inches high, have a sort of cheery, modern look. Sander's series 1:10 (1999–2000; pp. 128–31) also relies on computer production, but her small 3D "copies" of people are fabricated in plastic resin by a computer-driven industrial model maker, using data from live human subjects scanned by a sixteen-camera digital scanner, then painted by an airbrush artist. The results are weirdly realistic in a way unlike photography or anything else, and Sander is neither present during scanning nor involved in the process beyond selecting her subjects, until she sees and okays the final result. Hendricks uses another form of scanner to track his pupils as he looks at an object or image, or reads, and the resulting data is printed by a computer plotter, resulting in "eye drawings" that fulfill his desire to eliminate handwork and draw directly with his eyes (pp. 82–85).

These artists don't think of themselves as "high-tech" artists, but all of them take advantage of what technology can do for them. They might be described as conceptual artists, particularly Hendricks, but in fact they fall into a postconceptual middle ground that is more and more common these days. Like that of many artists today, their work is driven less by devotion to a distinct medium or style than by the will to articulate certain ideas and situations in visible, tangible form. They use whatever medium, tool, or method is needed to embody a given idea most effectively. The work that results is likely to present as "sculpture," but it could also take the form of video, installation, photography, or ensembles of found objects.

The disengagement of much contemporary art production from both handmade media and traditional notions of personal style clearly owes a great deal to the range of image-making technologies available today, as well as to conceptual art's deep impact and insistence that art is about ideas rather than craft. At the same time, it is clear that

For all earthly, and for some unearthly purposes, we have machines and mechanic furtherances; for mincing our cabbages; for casting us into magnetic sleep. We remove mountains, and make seas our smooth highway; nothing can resist us. We war with rude Nature; and, by our resistless engines, come off always victorious, and loaded with spoils. **THOMAS CARLYLE, 1829**

many contemporary artists are responding to the superabundance of material goods, information, and images in the world today, an upwelling of pictures and products that is itself inextricably linked to technological culture.

In *010101* this tendency is further visible in the serpentine networks of Sarah Sze's sculptural installations, constructed in part from off-the-shelf hardware, knickknacks, and dime-store trinkets (pp. 132–33); in the thousands of images scavenged from the Internet and television in Hu Jie Ming's mazelike installation (pp. 86–87); and in Rebeca Bollinger's tiny, enchantingly generic drawings of computer "thumb-nail" images based on image-bank searches using keywords such as *important documents, clouds,* and *need* (pp. 50–51). The after-effects of mass-media culture are likewise apparent in Rodney Graham's spooky video installation (pp. 78–79), as the sounds of hovering helicopters and searchlights sweeping the foliage forebodingly portend a cinematic narrative that never arrives, pushing psychological buttons that decades of television and movies have embedded firmly in every viewer's consciousness. This body of work would be both impossible to produce and inconceivable as idea without a backdrop of consumer technologies, mass media, and the behaviors they inculcate. It is not necessarily about machines or technology, but it bears active witness to the presence of both in the world today. Even when this art is handmade, it evokes the specter of the technological, whether ironically, perversely, or appreciatively.

All of this work reflects a larger stream of visual hyperconsciousness and oversaturation apparent in contemporary art today—the visual art equivalent of sprawl in an era of "image spam" and cheap reproduction technologies. This art is additive, not subtractive or reductive. It is excessive and hyperbolic, not minimalist. It has internalized the narrative structures and addictions of popular culture and film, pulled them inside out, and used them for its own ends. It is trying to actively reflect, not escape, the conditions of daily life in a society that pumps out a frightening amount of new material goods, entertainment, real or spurious innovation, and sheer visual information.

The Internet is the wild card in contemporary art, and the ultimate expression of a culture addicted to data and drunk on images. It provides visual artists with more power to make, borrow, appropriate, manipulate,

INCREAS INGLY WE ARE BORED STIFF.

Increasingly we are bored stiff. We may be leading longer lives, but our lives are increasingly empty. There is a monotonous, flaccid tone to our lives. We are tired, made weary of constantly adapting to change. We are constantly asked to accommo-date technological change, apparently arbitrary change. This flatness or deadness of heart is unnerving. Don't check for my pulse. I just want to be a dial tone. **TOM SHERMAN, 1999**

WE MAY BE LEAD ING LONGER LIVES, BUT OUR LIVES ARE INCREASINGLY EMPTY. THERE IS A MONOTONOUS, FLACCID TONE TO OUR LIVES. WE ARE TIRED, MADE WEARY OF CONSTANTLY ADAPTING TO CHANGE. WE ARE CONSTANTLY ASKED TO ACCOMMODATE TECHNOLOGICAL CHANGE, APPARENTLY ARBITRARY CHANGE.

THIS FLATNESS OR DEADNESS OF HEART IS UNNERVING. DON'T CHECK FOR MY PULSE. I JUST WANT TO BE A DIAL TONE.

and distribute images and ideas than the most utopian fantasies of pre-networked, analog times. Artists commissioned to create new pieces on the Internet for this exhibition include Mark Napier (pp. 112–15), whose *Potatoland* (1995–) looks critically at data sprawl on the network in projects such as the *Digital Landfill*, essentially a garbage dump for trashed pixels. Entering the site, Web surfers are brightly if ludicrously encouraged by Napier to "Clean up the Web! Dispose of your unwanted e-mail, obsolete data, HTML, SPAM or any other digital debris just by clicking the *Add to Landfill* button. All refuse is automatically layered into the Digital Landfill composting system." A view of the *Landfill* itself reveals a seemingly endless, chaotic layering of text, images, and still-functioning links. Like those of a number of artists working on the Web, Napier's projects offer a critical look at the underlying ephemeral, code-based nature of the Internet and a sardonic riff on its digital malleability.

At *Entropy8Zuper!* Auriea Harvey and Michaël Samyn offer a radically divergent vision of the Internet as a site for the production and distribution of immersive, narrative artworks of a highly personal nature (pp. 70–71). Clicking onto their site, visitors are provided with a checklist suggesting the need for "fast computer; DHTML browser (Navigator recommended); Macromedia Flash 4 or better; a physical need for wonder and poetry." Typically the browser will automatically check the first three (assuming all required software and hardware are present), allowing visitors to assess their own response to the fourth. In their work, evocative background music and layers of dramatic imagery intertwine through the course of an elliptical story line based loosely on Harvey and Samyn's own lives and romance. Emotionally engaging, their work seeks to fuse art and entertainment, reaching audiences with immersive environments that are, in Samyn's words, "as good as good novels."[1]

010101: Art in Technological Times is the manifestation of a figure-ground relationship. Technological society, and all that comes with it, is the ground. The figure is alternately the single work of art and the larger condition of art in the world. And, finally, it is the act of looking at art, by people whose expectations, attention spans, and internal rhythms have been rewired by their interactions with new technologies, and with the sprawling data paths of the Internet, people whose sense of history and of the visual has been conditioned by a technologically saturated world. As the ground changes, so will the figure.

1.

Quoted in
ALEX GALLOWAY,
"A Dream Come
True: Interview with
Michaël Samyn,"
at www.rhizome.org.

END

ERIK

ERIK ADIGARD

THE WORK OF ERIK ADIGARD IS CARRIED OUT PRIMARILY IN THE UNCHARTED SPHERE of "information architecture." With a background in fine art and extensive experience as a graphic designer, Adigard has contributed to numerous publications, both online and offline, including *Hotwired* and HotBot (*Wired* magazine's online counterpart and the publishing group's search engine, respectively). His investigations in cross-media publishing and design have led him to rethink the way one approaches the inherent conditions of each medium, as can be seen in projects such as his recent "interface design" for Aaron Betsky's book *Architecture Must Burn* (2000). The vehicle for most of Adigard's recent investigations is M.A.D., a graphic design firm he cofounded a few years ago with Patricia McShane. He has been exploring the screen as the primary interface for the remote management of the constant flux of information we live in, as well as conducting further research in cross-media publishing strategies.

Adigard is interested in the notion of time on the network, how access to information and processing is affected by such a notion. *Timelocator* (2001) is a project wherein visual information is directly (and graphically) affected by the passing of time: hours, minutes, and seconds are represented by images, which move on the screen like hands on a dial. The user is also compelled to consider the lapse between the server's and the client's local time, eliciting reflection on issues of location as a means to understand one's relationship to space and distance. This project may be seen as the natural continuation of *The Site of Hours* (1999), a piece commissioned by the RGB Gallery (*Hotwired*), which Adigard made in collaboration with David Kushmerick. As is noted in the introduction to the piece: "People expect computers to be fast. . . . However, it is no secret that looking at Web sites can often be a frustrating and slow process. So why would you want to make a digital art piece that emphasizes the fact that looking at a computer screen can often require patience?"[1]

Taking time as a starting point for the creation of an interface, Adigard also suggests that the conditions of viewing and experiencing content online are fashioned by the various "frames" applied to this content. Form affects comprehension: "The medium is code," he has stated. Indeed, if the screen is one of the parameters that conditions access to information, the browsing software, and the subsequent encoding of the Web "page," has a definite impact on interpretation. With his time interface, Adigard proposes another logic for the processing of data. BW

ADIGARD

NOTES

1. All quotations are from the introduction to the
RGB Gallery project *The Site of Hours,* at
http://hotwired.lycos.com/rgb/hours/index_about.html.

Timelocator, 2001, digital stills from Web site

8/1
8/1
17/
3:3
w.
.sp
w.
hor
aho
art
ell
om
ail.com 04/04.08 www
titch.com 00/00:33 ww
hlink.com 18/18:23 wv
.cdm.sfai.edu 15/12:2
www.ix.netcom.com 1
4/15:08 www.submari

KEVIN

KEVIN APPEL

THE WORKS OF KEVIN APPEL OCCUPY PLACES within and between the practices of painting, architecture, and design. A project titled *House*—which was presented in 1999 at both Angles Gallery in Santa Monica, California, and at the Museum of Contemporary Art in Los Angeles—featured a suite of large-scale paintings, each offering a different view of the same hypothetical structure and accompanying garden. Appel uses the computer to aid in the design of the spaces and then reclaims them, as he has said, through the more personal and clearly more labor-intensive process of painting. Yet within a pictorial structure based on a disorienting two-point perspective and a repetition or even replication of forms, the paintings veer from physical reality to virtual reality, at once excluding and enveloping the viewer.

Appel is presently collaborating with Open Office of Architecture in New York on a project called *Houses x Artists,* for which twelve artists are designing dwellings that could in fact be built and occupied. The very beautiful designs Appel has made for his house thus far feature a series of pavilions made with structural glass of varying colors and opacities. Though relentlessly precise in its design, the house displays a near-total blurring of infrastructure and superstructure. The spaces or rooms that define the house, its patterns of circulation and its relationship to the outdoors are defined by choice, rather than by convenience, and are thus subject to change, representing a move away from modernist notions of control toward contemporary notions of possibility. The hand-made drawings for the project pictured here collapse the three-dimensional spaces of the house into to a series of overlapping rectangular planes, each transparent and varying in density from the others. Appel's imploded forms, almost unreadable as sections or elevations, suggest underlying principles, however nonstructural, of fluidity, indistinct-ness, and slippage. JB

APPEL

TOP TO BOTTOM:

House: South Rotation Red: 4 West View, 2000,
liquid acrylic on paper. Courtesy Angles Gallery,
Santa Monica, California.

House: South Rotation Red: 1 East View, 2000,
liquid acrylic on paper. Courtesy Angles Gallery,
Santa Monica, California.

House: South Rotation Red: 3 Northwest View, 2000,
liquid acrylic on paper. Courtesy Angles Gallery,
Santa Monica, California.

House: South Rotation Red: 2 Northeast View, 2000,
liquid acrylic on paper. Courtesy Angles Gallery,
Santa Monica, California.

ASYMPTOTE

I-SCAPES 1.0 (1999) IS NEITHER A MODEL NOR A DRAWING. It is a continually changing digital construct presented in a highly particular manner. It is a fluid extract from the continual flows of information and images that circulate around us. Architects Hani Rashid and Lise Anne Couture have created such digital projects as the *Virtual New York Stock Exchange* and the *Virtual Guggenheim Museum,* as well as "real" buildings. Their designs appear mainly on those screens whose displays take up more and more of our visual landscape and where what look like real and recognizable forms appear and fade away.

Rashid and Couture created *I-Scapes 1.0* by first collecting a sampling of the many images we confront every day: sneakers, buildings, cars, advertisements, and abstract forms. They then put these forms through an electronic blender, fusing them into an image that continually changes from one of the objects they selected into another. By using software that stretches one form into another (or "morphs" it, a term ironically derived from the Greek word for form), they created a construct that condenses our experience of a world so saturated with images that we apprehend it only as a blur.

I-Scapes 1.0 is, of course, not really an object, but only a collection of data points floating in the electronic ether. The architects chose to highlight the problem of an electronic artifact that has no real existence by presenting it on a mini DV (digital videotape) player encased in a glass vitrine. Thus the display mechanism, an object of consumer desire, becomes the static artifact, making us wonder even more about the ephemeral nature of the pleasures actually provided by a culture of endlessly produced and desired things. AB

ARCHITECTURE

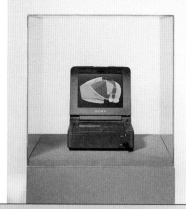

I-Scapes 1.0, 1999

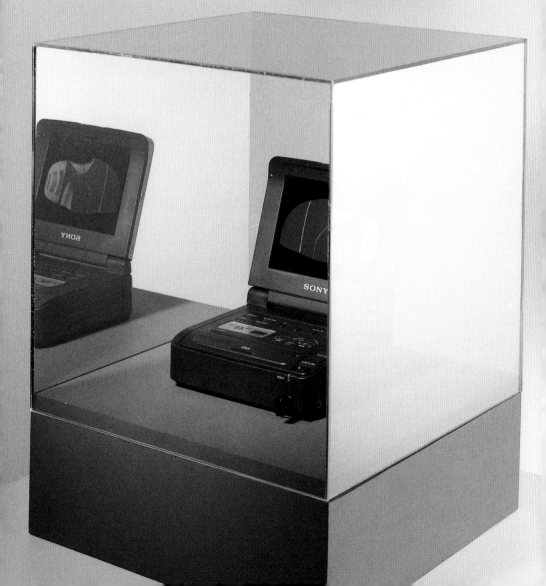

HEIKE

HEIKE BARANOWSKY

SHOT FROM THE SIDE WINDOW OF A MOVING CAR CIRCLING THE PERIPHERY OF PARIS, Heike Baranowsky's *AUTO SCOPE* (1996–97) charts a landscape of nondescript office buildings, warehouses, empty intersections, and the branches of overhanging trees, bare of leaves under a gray, cloudy sky. The piece is based on a single sixty-minute video loop, but Baranowsky copied the single-channel signal four times and projects them all simultaneously, side-by-side, to form a band of moving images on two adjacent walls. Two of the channels are flipped horizontally, creating a hypnotic kaleidoscope of alternately intersecting or diverging forms. Like everything else about *AUTO SCOPE,* it's an outwardly simple move, but it works perfectly.

The images push relentlessly forward, seemingly speeding up and slowing down depending only on how far things are from the camera. When they are close, scenery flies by at a dizzying pace; when they are far away, the view slows down, at times almost to a crawl. Occasionally the camera tracks a car pulling alongside Baranowsky's vehicle, and the foreground virtually stops moving as the two cars keep pace, while the background continues to zip past. Ingeniously, all of this is a function of the built-in structure of the piece—which is like a machine for creating happy "accidents" of visual rhythm, pacing, and pattern—not a deliberate, self-conscious result of editing decisions. Echoing the actual drive around the city, the tape is a loop. Its form is circular and open-ended rather than linear: there's no beginning, middle, or end, and you can enter the piece anywhere.

Baranowsky's Paris isn't romantic, or scenic, or famous. It isn't the Paris of Left Bank cafés, shopping on the rue de Rivoli, or parades along the Champs-Elysées. This isn't a Hollywood version of the City of Light, or the evening news. There's no story line here, just vision and motion. Drab scenery is transformed into a visual roller-coaster ride that gets more addicting the longer you watch. JW

BARANOWSKY

ABOVE AND OVERLEAF: *AUTO SCOPE,* 1996–97, video stills

ANNETTE

ANNETTE BEGEROW'S *CONSTANT MEMORY, ENTERING THE SURFACE* (1999) is a rigorous meditation on the abstract nature of digital information and how computers translate tiny squares of differing tones into recognizable images. The installation features a computer that projects a constantly shifting, gridlike display of monochrome squares and rectangles in varying sizes and shades of gray, white, and black. In dimension and scale, the projection evokes a large abstract painting on the wall, a video projection, or a small movie. The squares grow smaller and larger in an apparently random sequence. At times they seem to be zooming in or out, or they may shrink and begin to resolve fleetingly into an image of a recognizable scene, a "picture." Mostly the display fluctuates in a visual zone that remains totally abstract, geometric, flat, and poetically minimal. The eye strains to find an organization and a logic to the mutating display, tantalized but frustrated.

Tellingly, the ever-changing display of *Constant Memory* is based on a single digital image, sampled and resampled continuously *and randomly* in real time by a computer. This process of constant decision making by the computer is projected live as it happens. Again and again, the computer employs a randomly generated algorithm to sample and project different interpretations and subsets of the code making up the underlying, mostly unseen picture. Unlike a video installation or a movie, *Constant Memory* offers a different viewing experience every time.

Constant Memory reflects the fact that, in material terms, there is "no there there" when computers produce an image on a screen—just zeros and ones that the computer

BEGEROW

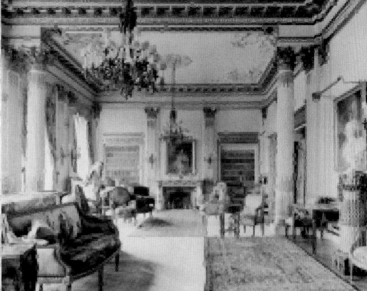

*Constant Memory,
Entering the surface,*
1999, digital stills

BACKGROUND: source
image (Anonymous,
House Cliveden, c.1920,
contact print from
glass-plate negative)

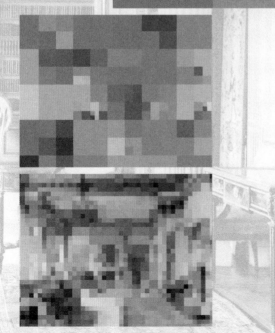

reads in real time to display tiny pixels of varying brightness and hue. If the computer has sufficient memory and computational power to display enough pixels with enough different tones, it can organize them in ways that mimic traditional photographs, movies, or paintings. Seen from close up, however, those pixels dissolve into abstract squares that are themselves only ephemeral projections.

With elegance and restraint, Begerow makes the fundamental nature of computer-generated images tangible in all their instability, abstraction, and geometric orderliness. Her piece is about what is really happening behind the scenes (and screens) when the production of visual experience moves from the analog world of continuous tones to the digital world of zeros and ones. *Constant Memory* is about what happens when a picture is no longer an object, but a computational process. JW

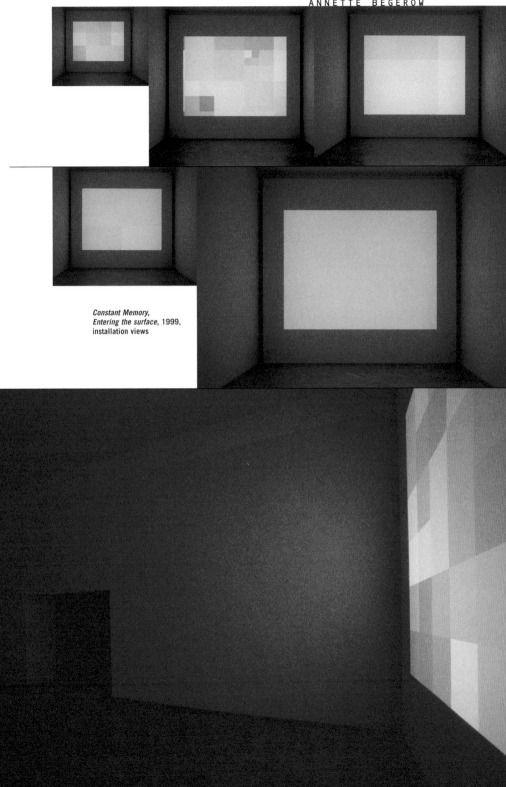

Constant Memory,
Entering the surface, 1999,
installation views

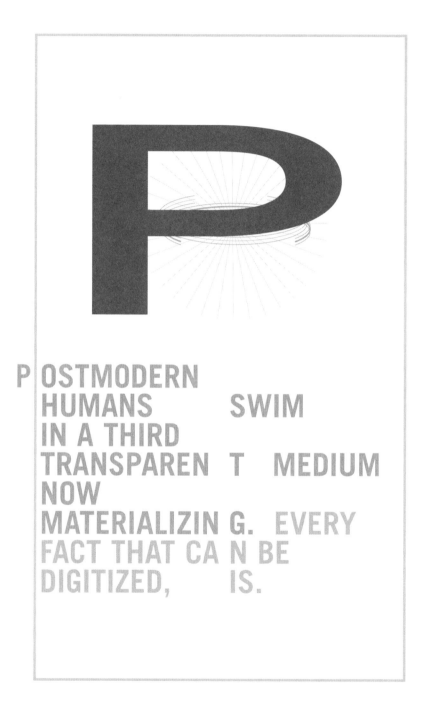

P OSTMODERN
HUMANS SWIM
IN A THIRD
TRANSPAREN T MEDIUM
NOW
MATERIALIZIN G. EVERY
FACT THAT CA N BE
DIGITIZED, IS.

Postmodern humans swim in a third transparent medium now materializing.
Every fact that can be digitized, is. **KEVIN KELLY, 1992**

THE AGE OF THE RECURSIVE

AARON BETSKY

ACCORDING TO BRIAN ROTMAN IN HIS 1987 BOOK *SIGNIFYING NOTHING: THE SEMIOTICS OF ZERO,* three parallel developments in Western culture changed our relation to reality beginning in the thirteenth century: the use of zero as the "sign of nothing," the emergence of paper or virtual money, and the use of the vanishing point in representation.[1] All three of these developments allowed us to conceptualize the relativity and artificiality of the world we create for ourselves. They disentangled the reality of human creation—tied as it remains to both our mortality and our rational pursuit of a controllable realm of experience—from the infinite, the unknowable, and the unreal. God and man became

1.
BRIAN ROTMAN,
*Signifying Nothing: The
Semiotics of Zero* (1987;
REPRINT, STANFORD:
STANFORD UNIVER-
SITY PRESS, 1993).

With its cartoon-like simplicity, its child-like forms of graphic representation, the virtual environment is simply another icon, a piece of signage, for the brutally alluring "there" that the dream of the future is, and in which, by definition, one cannot be.
FRANCES DYSON, 1998

separate in a productive manner. Thus the very notion of the modern, as that which humankind can make out of base existence, came into being. Now the zero has been paired with the numeral one to create a new code of artificiality. Digital domains open up new realms of exploration and exploitation that to some make the discoveries of the last centuries seem like small conquests tied to physical territory. Yet what is remarkable about digital code is its recursiveness. It reduces all that can be said or calculated to the combinatory processes of just these two signs for "on" and "off." It produces out of them a set of projected images of which one cannot say whether they are real or not. What one can say is that they are purely the product of programming and exist only in that state of projection. What one can also say is that they are not necessarily the products of a new reality, because they are not things, but they do represent a re-signing of what already exists.

This is also true on a practical level. The result of the applications of computers on the physical world has been to smooth, stretch, and deform what exists. This is true whether we speak about our perception of time or of the objects, from cars to buildings, we produce with the help of computers. Ideally, the computer lets data come together into form, thus making abstractions into real forms or effects. It is also the case if we speak of the marketplace, where the main effect of the Internet seems to be the elimination of middlemen so that products and services appear more clearly, quickly, and cheaply. The computer, in other words, reassembles, redistributes, and represents what already exists.

On the level of how we think about such processes, the computer has replaced the endless quest to zero in on objects with ever more powerful microscopes and telescopes, as well as the attempt to more truly represent the world, with a continual deconstruction and reconstruction of our reality. Instead of mirrors and maps that tell us clearly where we are, we now consult continually changing collages of information and identity, signs and symbols, that condense our reality into ever tighter, more discrete, and easier-to-reassemble packages.

It is perhaps no accident that this kind of recursive and recombinant power parallels our realization that we cannot continue to convert more and more "raw" resources and territory into the artificial landscapes over which we have dominion. Instead of depleting our natural resources, cutting forests and polluting our air, we need to reuse what

You may live to drive a plastic car powered by an atomic engine and reside in a completely air-conditioned plastic house. Food will be cheap and abundant everywhere in the world. . . . No one will need to work long hours. There will be much leisure and a network of large recreational areas that will cover the country, if not the world.
OPERATION ATOMIC VISION: A TEACHING UNIT FOR HIGH SCHOOL STUDENTS, 1948

already exists. The ecological imperative argues against the production of new things and spaces that has been so essential to the economic and ideological rationale of modernity. Instead it poses the possibility that we can find a sense of identity through a creative recombination of what already exists.

At the same time, the miniaturization of processes of production frees up vast amounts of space within what we have already made: instead of library reading rooms, we now have terminal screens, and instead of factories, we now have compact assembly points and warehouses. Space becomes smoother and more open to changing uses, and codes of utilization and safety make what appears more and more the same. The question of how to reuse or give meaning to this space is being solved by the growth of entertainment and consumption as the prime occupiers of space. Our public arena (whether in our home or in the city) is now that of home entertainment centers, restaurants, shops, and sports arenas. We use space to make up stories about ourselves, to construct personal and social identities.

The emergence of recursive code and the need to reuse are thus finally finding a parallel in the business of making sense of our reality and ourselves. In the modern age, our quest is no longer to make ourselves or our world better, but to understand who and what we are. As the English critic Anthony Giddens has pointed out, we understand our reality as already existing and seek to write scenarios that allow us to act out a role within that reality.[2] We assume—or assemble out of the images and artifacts of mass production—an identity, and the continual construction, deconstruction, and reconstruction of that personal reality is our life's work. This is why the identities of the author, the viewer, and the thing portrayed are now so central to the work of art: it is here that the anxiety about the reality and feasibility of this project or identity construction comes into play.

If the invention of zero opened an essential divide between reality and human construction, then the coupling of zero and one poses the question of what the difference is between what we project and who we are. The arena of art is now what the architect John Hejduk called "the space between the face and the mask."[3] The fundamental problem underlying our existence is no longer the gulf between the infinity of God, time or space, and the reality we can experience, but where and how we

Computer networking responds to our deep psychological desire for transcendence—to reach the immaterial, the spiritual—the wish to be out of body, out of mind, to exceed the limitations of time and space, a kind of biotechnological theology.
ROY ASCOTT, 1989

2.
ANTHONY GIDDENS, *Modernity and Self-Identity: Self and Society in the Late Modern Age* (OXFORD: BLACKWELL, 1991).

3.
A phrase he often used in lecturing about his work; see JOHN HEJDUK, *The Mask of Medusa: Works, 1947–1983* (NEW YORK: RIZZOLI, 1985).

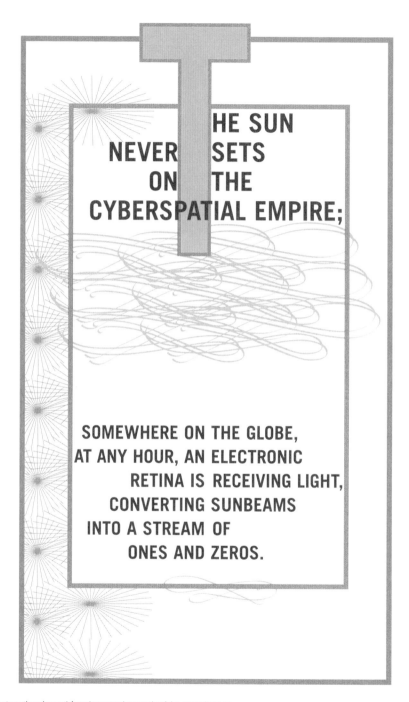

THE SUN NEVER SETS ON THE CYBERSPATIAL EMPIRE;

SOMEWHERE ON THE GLOBE, AT ANY HOUR, AN ELECTRONIC RETINA IS RECEIVING LIGHT, CONVERTING SUNBEAMS INTO A STREAM OF ONES AND ZEROS.

The sun never sets on the cyberspatial empire; somewhere on the globe, at any hour, an electronic retina is receiving light, converting sunbeams into a stream of ones and zeros.
THOMAS J. CAMPANELLA, 2000

can actually inhabit the chasm that has become our reality. Its sign is the intertwined strands of DNA codes, which we will soon be able to reproduce. The variables are limited and (almost) known, but the possibilities of making what we do not yet see out of what already exists are—in many ways frighteningly—endless. It is this question of the value, meaning, and identity of recursive codes that art must address.

END

JEREMY

IN THE EXPANDED SENSE OF THE WORD, Jeremy Blake is a painter. He refers to his digital C-prints as "paintings," and his computer-animated projections clearly acknowledge the color-field painters of the 1960s. Blake's digital animations seduce the viewer with evolving fields of color that merge California noir and ultramodern environments, still and moving images, and traditional painting and contemporary digital media.

Often shown on flat plasma screens that suggest the dimensions of a framed work, Blake's animated "paintings" are filled with futuristic architecture, flattened interiors, and illusions of depth. Translucent layers effortlessly blur and morph into one another. Doors slide open to reveal other architectural spaces, grids dissolve, and screens blip and whoosh as the hallucinatory imagery slips from abstraction to representation and back again.

Yet Blake's work is eerily seductive. There is indeed the implication of something darker, unsettling, at times even ominous, in the work, which suggests the disintegration of contemporary physical reality into simulated worlds. In the spirit of our increasingly blurry and artificial contemporary culture, his aesthetic is an irresistible haze in which definitions melt and borders dissolve. Ultimately Blake has reinvented the tradition of painting by using software in a manner that invites us to question what it means to be an artist working in the shadow of the digital age. KF

BLAKE

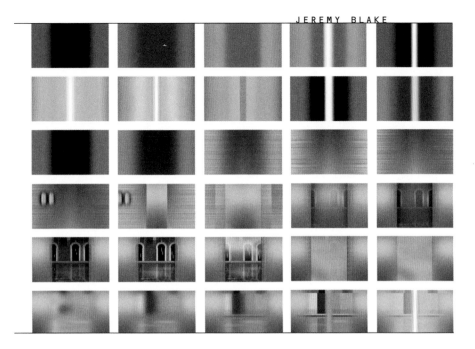

ABOVE: *Liquid Villa,* 2000, digital video stills

BELOW AND OVERLEAF: *Guccinam,* 2000, digital video stills

REBECA BOLLINGER

REBECA BOLLINGER'S RECENT WORK addresses the basic human desires for information and order. In the series Similar/Same (1999–2000), which includes both video pieces and draw-ings, she examines the incomprehensibly vast culture of images that exists on the Internet, with an emphasis on the classification strategies used by individuals and content providers to organize and access them.

Most of Bollinger's drawings feature a grid (often incomplete) of delicately ren-dered thumbnail-sized images in colored pencil on vellum. Titles such as *Important Documents, People at Work,* and *people communicating* offer descriptions that reflect categories of images surveyed by Bollinger or keywords that she entered into visual search engines to create her own categories. The resulting rows of thumbnails resemble a screen's worth of images from each search. The types of groupings vary widely. Among those that look at personal possessions are *My Van* and *tv rv* (the televisions pictured in the latter come largely from postings aimed at commerce). Bollinger's interest in personal sites—such as that of a real estate broker named Ed Glaze, whose "photo album" appears on Alta Vista—emphasizes the idiosyncratic ways in which people make use of available technologies and the incongruity between relatively private material and a potentially enormous audience.

With consistent humor, Bollinger acknowledges the leveling quality of Web-based im-agery. The images in *Important Documents,* for instance, are reduced to almost pure form. We couldn't know from the way the piece looks that the images were culled from the Web site for the National Archives and Records Administration and were accompanied within the site by descriptions ranging from the popular favorite "Elvis Presley, list of telephone numbers while in Washington D.C., 1970 (close-up)" to the undeniably important "Declaration of Independence." All are virtually illegible and indistinguishable in this virtual form, as they reflect a new era in archival representation.

By making objects out of these various images, Bollinger acknowledges and immor-talizes them. But even as she distances them from an active life in cyberspace—stripping them of their capacity to be clicked on, enlarged, downloaded, printed out, or e-mailed—she gives them each an aura, no matter what their original source. JB

BOLLINGER

Important Documents, 2000

JANET CARDIFF'S CONTRIBUTION TO *010101* IS A "VIDEO WALK," an original, immersive, site-specific art form. Museum visitors who wish to "do" Cardiff's piece are given a small digital camcorder equipped with stereo headphones. It contains a tape that displays a short trip through the Museum, complete with a soundtrack featuring Cardiff's voice and the sound of her footsteps traversing the Museum's galleries and architectural spaces. Viewers synchronize their journey through the Museum by lining up the onscreen images of the Museum with the "real thing" in front of them, essentially "following" Cardiff's recorded path as they move through the space. Along with ambient recorded sound, Cardiff has added sounds collaged from other sources, such as old movies and radio; music; and deliberately scripted passages. The result is a mesmerizing blend of reality and fiction, delivered in a form unlike anything else in contemporary art.

The engrossing quality of these works is derived from sure-footed technological execution and Cardiff's beguiling narrative sensibility, which is alternately deadpan and deliciously seductive. Her tone of voice shifts from neutral to private, even intimate tones, fostering a sense that she may have mistaken the participant for someone else, someone she knows far better than any stranger taking a museum tour. The sense of voyeurism this produces is enticing and unpredictable. She speaks at times directly to her listeners, telling them things about what they are seeing, and instructing them on the route. Other passages cut away to the past tense or a different reality altogether, collaging in bits that seem to have been dredged up from memory or imagination, forming a stream-of-consciousness background to the sense of real time and real space in the foreground. The video image takes the same liberties, first establishing a direct relationship to the space around the visitor, then fleetingly jump-cutting to another reality, which might be either memory or just the artist's fantasy.

Cardiff's video walks, of which the SFMOMA piece is only the second, are an out-growth of her earlier audio walks, narrative sound works that quickly became a favorite at international exhibitions in the late 1990s. Both art forms employ a binaural record-ing technique in which high-quality microphones are placed simultaneously on each side of the head, picking up stereophonic sound with the full three-dimensional quality per-ceived by human ears. When played back on a high-quality audio source, the effect is un-canny and utterly convincing: live ambient sound becomes virtually indistinguishable from the recorded soundtrack, producing a weirdly thrilling uncertainty concerning what is recorded fiction and what is "reality." When this is combined with a recorded visual track in her video walks, the result is like getting sucked into a movie playing itself out in Cardiff's brain, in which participants have no idea what role they are playing and where she will take them. JW

In Real Time, 1999, audio and video walk
(Carnegie Library of Pittsburgh). Courtesy Galerie
Barbara Weiss, Berlin.

CHRIS CHAFE

CHAFE / NIEMEYER

CREATED BY COMPOSER AND RESEARCHER CHRIS CHAFE AND DIGITAL ARTIST GREG NIEMEYER, *Ping* (2001) is a site-specific sound installation that is an outgrowth of audio-networking research at Stanford University's Center for Computer Research in Music and Acoustics and interactive and graphic design experiments originating from the Stanford University Digital Art Center.

Ping is a sonic adaptation of a network tool commonly used for timing data transmission over the Internet. As installed in the Museum's fourth-floor terrace, *Ping* functions as a sonarlike detector whose echoes sound out the paths traversed by data flowing on the Internet. At any given moment, several sites are concurrently active, and the tones that are heard in *Ping* make audible the time lag that occurs while moving information from one site to another between networked computers. Within the *Ping* environment, one can navigate through the network soundscape while overlooking San Francisco, a cityscape itself linked by the same networks that constitute the medium. Visitors to the installation can expand or change the list of available sites as well as influence the types of sound produced, choosing different instruments, musical scales, and speaker configurations in the surround-sound environment.

Current explorations pertaining to sound synthesis and Internet engineering are the foundation of the *Ping* installation. The research that led to this installation is, however, just one part of a larger effort to investigate the usefulness of audio for networking and, reciprocally, ways in which the Internet can abet audio. It is precisely this dialectic surrounding *Ping* that illustrates the increasingly common intersection of art and technical advancements, an interdisciplinary breeding ground where computer-based technology functions both as a stunning artistic medium and as a research tool. KF

GREG NIEMEYER

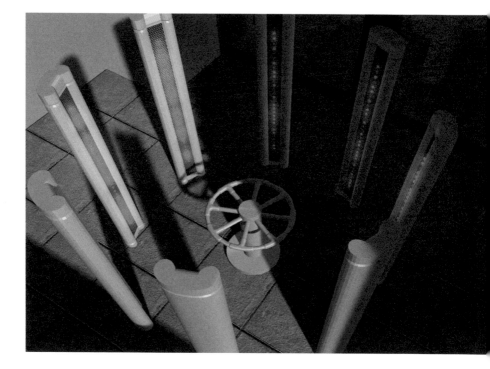

Ping, 2001, digital rendering

THERE IS A NEW PSYCHOLOGICAL PHENOMENON EMERGING IN THIS ERA OF HYPER-TELEMEDIA, INFORMATION ABUNDANCE AND OVERLOAD. PEOPLE OF ALL AGES AND WALKS OF LIFE ARE 'BLANKING'_____ THAT IS, THEY ARE SHUTTING DOWN OR EXPERIENCING MOMENTARY RUPTURES OF CONSCIOUSNESS, OR IN VERY SEVERE CASES, 'BLANKING' SOMETIMES LASTING FOR DAYS.

THIS is not attention deficit disorder (ADD) or daydreaming (dd), but a sudden breakdown of consciousness brought about by sensory and cognitive over-extension induced by hyper-connectivity. People rarely choose to focus on one coherent stream of information these days, but rather gather data from multiple sources simultaneously. Instead of simply listening to the radio or watching TV, we read a newspaper, magazine or book while listening and/or watching while we have something to eat and we have a conversation on the phone while we stroke our dog's tummy with our bare foot. This is how we function in our leisure time—we choose to compose our immediate information environment from multiple sources, mixing our multi-layered reality on the spot.

There is a new psychological phenomenon emerging in this era of hyper-telemedia, information abundance and overload. People of all ages and walks of life are 'blanking'_____ that is, they are shutting down or experiencing momentary ruptures of consciousness, or in very severe cases, 'blanking' sometimes lasting for days. This is not attention deficit disorder (ADD) or daydreaming (dd), but a sudden breakdown of consciousness brought about by sensory and cognitive over-extension induced by hyper-connectivity. People rarely choose to focus on one coherent stream of information these days, but rather gather data from multiple sources simultaneously. Instead of simply listening to the radio or watching TV, we read a newspaper, magazine or book while listening and/or watching while we have something to eat and we have a conversation on the phone while we stroke our dog's tummy with our bare foot. This is how we function in our leisure time—we choose to compose our immediate information environment from multiple sources, mixing our multi-layered reality on the spot. **TOM SHERMAN, 1997**

AMBIENT ART AND OUR CHANGING RELATIONSHIP TO THE ART IDEA

BENJAMIN WEIL

THE OMNIPRESENT MEDIA STREAM TO WHICH WE HAVE BECOME ACCUSTOMED has gradually fashioned our ability to process a number of data flows simultaneously and somehow orchestrate them so as to generate meaning. In this state of constant parallel processing, the information streams competing for our attention create an increasingly noisy condition. This is the landscape artists are working in nowadays: an environment saturated with sounds, images, animations, and so on. Given that silence, or a retreat from technology, no longer seems to be an option, unobtrusive artworks created with readily available media could be envisioned as a remedy[1] for the feeling of being overwhelmed by this constant flow: hence, the notion of "ambient" as an operating principle.

1.
Remedy for Information Disease, a project by Russian artist ALEXEI SHULGIN, offers a witty perspective on the reconditioning of images as a means to deal with information overload (http://basis.desk.nl/~you/remedy/).

Brian Eno (p. 69) first applied this notion to sound with his release of *Music for Airports* in 1978. With this album, Eno set out to redefine our relationship to music, recognizing that we do not always listen intently to a recording but instead experience various degrees of hearing. As the album plays, the flow of recorded sounds effectively creates a sonic atmosphere that pervades the architectural environment, blending in, becoming part of that space and that moment. Its omnipresence somehow caters to a wide range of listeners, from the most attentive to the most oblivious, bringing to each a different experience of the same score.

While *ambient* is now commonly understood as a term describing sound, the concept can easily be applied to other art forms. This expanded meaning may help us comprehend the perceptual shifts brought about by the multimedia, multilayered environment in which we live. Ambient art has the potential to reveal mechanisms of association and perception, giving us a different perspective on how to pay attention to our surroundings and attain a different level of consciousness. What are we looking at? What are we paying attention to? And why?

Eno's interest in a musical form that subtly infiltrates the auditory environment somehow evokes the founding principles of Minimalism, as carried out by artists such as Dan Flavin and Carl Andre. Both artists sought to modify the perceptual experience of a given space by altering it with a minimal presence—floor sculpture for Andre and neon light arrangements in the case of Flavin. One could then posit Minimalist art as the first ambient art form: the art object is inconspicuous, yet it affects the condition of the space and modifies our perception of the environment. The degree of influence varies with the level of attention one pays to that perceptual shift. It may also be that this type of art (whether sculptural or auditory) has a subliminal effect on any visitor to a given space.

More recently, artists have approached public art installations in a similar fashion. Foregoing a tradition of monumentality, they have been exploring approaches akin to an ambient strategy, focusing on ways to insert their projects within the chaos of an overmediated public sphere. Billboards, designed to advertise commercial products, have been used by artists such as the late Felix Gonzalez-Torres to "sell" ideas. Marquees of abandoned theaters are ideal surfaces for the placement of

The meta-artist's contribution is the software: the instructions, the rules, the grammar. Will the media used for representing structures—sound, visual images, virtual worlds— be the art? Or are they simply ways of interpreting the software? Will the art of the future be the software? **STEVEN R. HOLTZMAN, 1994**

inconspicuous messages; stickers, posters, and other forms of street culture become compelling instruments in the hands of artists. The example of Jenny Holzer—who has become world-renowned for her use of electronic message boards in locales such as Las Vegas, Amsterdam, and New York—also comes to mind.

Adopting the tactics of other forms of cultural production has become a core strategy in art making today. In the public sphere—outside the context of the museum or gallery—the resulting works may not "read" as art. Playing off this confusion has become integral to the practices of many artists working in the larger culturescape, as they explore the boundaries of art. This interest has also led them to investigate both the strategies of mass media and its potential as a venue for art. Indeed, the idea of inserting an art project within the context of the mediascape is probably what appealed to a number of the early practitioners of video art. Aside from using video to document otherwise ephemeral art forms such as performance, artists could also use it to engage with television—a medium that was not initially conceived for experiencing art. Working outside the traditional sphere of art, artists have been compelled to change their methodology. If the work is to function on a television screen, or in a similar public venue such as the Internet, artists must be aware of tactics developed by the mainstream "content providers," if only to distance themselves from those practices.

Enhancing our awareness of our environment, from the urban landscape to the more pervasive mediascape, remains a concern of many artists. Shifting from the notion of representation to that of decontextualization (a modern idea in many ways epitomized by Marcel Duchamp's readymades), artists now often choose to "recontextualize" and "de-present." The juxtaposition of one form of cultural production—experiential, experimental, and reflexive—to another—mainstream, mass-produced—may be what characterizes the notion of ambient. This artistic strategy enables a more critical approach to culture at large, encouraging the viewer-participant to understand the "real" in a different manner. The effect may even function in reverse, as when the experience of seeing large metal plates on the sidewalk reminds one of a Carl Andre sculpture. In such cases, Oscar Wilde's famous dictum that "Life imitates Art" takes on a whole new significance.[2]

Who can deny that we are a nation addicted to television and the constant flow of media? Now I ask you, my fellow Americans, haven't you ever wanted to put your foot through your television screen?
ANT FARM, 1975

2.
OSCAR WILDE, *The Decay of Lying,* in *Intentions* (LONDON: METHUEN, 1913), 30.

The evolution of the media has decreased the significance of physical presence in the experiences of people and events. One can now be an audience to a social performance without being physically present; one can communicate "directly" to others without meeting in the same place.
JOSHUA MEYROWITZ, 1985

The technical refinement and increased availability of recording and playback equipment in the second half of the twentieth century afforded the possibility of a mediated experience of both sound and images. Prior to that, only firsthand, real-time experience was available. These technologies have undeniably transformed our relationship to cultural production. At first, mediated work was a mere copy of the live experience, including "natural" sounds such as the rustle of the audience. Portability and ease of access to equipment then fostered the development of a new vocabulary for this kind of cultural production. Artists gradually started using recording as a full-fledged medium, adopting techniques of sampling, collage, and remix; making full use of recording and editing tools; and dismissing the notion that the only "real" performance is the live one. In that sense, Eno's ambient music stems from the evolution brought by recorded and portable music: the moment music became accepted as a mediated experience, no longer attached to the notion of "live," or ascribed to a specific place at a specific time, the listener's experience necessarily evolved.

Portability and mediated cultural experience have also given rise to multitasking. One does not just listen to music; it has become part of a set of simultaneous experiences. Muzak was the first systematic form of "environmental" music streaming.[3] While it is one of the crudest examples of sound permeating an environment, it undoubtedly inspired Eno's investigation of an ambient musical or sound form. Muzak was conceived to "enhance" the experience of public, often commercial spaces. And a stream of ubiquitous yet far from compelling music now accompanies our daily lives, following us from the elevator to the supermarket to the airport lounge. With *Music for Airports,* Eno became the first artist to consciously attempt to derive artistic work from this form, paving the way for a number of related musical experiments.

With the advent of multimedia, artists may now create work wherein each consciously dissociated element informs our perception of the others, as they evolve at different tempos or along different paths. Many sound artists employ projected images, whether still or moving, in such a way as to turn a visual element into just another fragment of the overall experience of music—a significant departure from the primacy typically accorded to visual elements. Conversely, visual artists may introduce sound to projects that are primarily visual and use

3. Muzak is the name of the company that invented the concept of creating music streams for public spaces. Founded in the 1930s, this company has gained prominence since the 1950s, hence lending its name to any pervasive experience of music in the public space.

this layer of information to reflect upon how one form of perception affects the other. The function of sound in such works as the "digital paintings" of Jeremy Blake (pp. 46–49) is to create yet another layer of experience, which somewhat underlines the ambient quality of the work. As the surface subtly evolves, sound serves as a guiding element that introduces a different temporal dimension to the almost imperceptible progression of the animation. It also stresses the moments of visual transition in the work, an approach that echoes the way music is used in mainstream cinema.

In a similar fashion, technology often enhances our awareness of otherwise indiscernible shifts in culture. As the use of the term *interactive* has become more prevalent in the spheres of art and other creative disciplines, so too has the use of *ambient* as a means to describe that which is not interactive. This raises the question of whether the notion of ambient can provide an intellectual framework for understanding work from previous eras or whether it relates only to work produced in the age of multimedia. Can one think of painting, or any analog or still art form, as ambient? Similarly, does the notion of interactivity highlight a participatory quality in art that has always existed but is simply more apparent today with the advent of the computer as an art-making instrument? Or is it that the increasing use of the computer has created a need for a kind of art that is more overtly participatory?

History is about looking back and establishing links between events that may not initially appear to be related; it is a lens that allows us to chart evolutions of consciousness that might not have been evident before a given technological development occurred. New filters of meaning, signaled by the emergence of new vocabularies, reflect the shifts in signification that reshape our perception of culture. More than a term that can be attached to a specific movement or strategy, ambient may be a state of culture. As French Fluxus artist Robert Filliou has remarked, "Art is what makes life more interesting than art."

Postmodernism swims, even wallows, in the fragmentary and the chaotic currents of change as if that is all there is.
DAVID HARVEY, 1990

END

CHAR

CHAR DAVIES

CHAR DAVIES IS AN ARTIST WHO HAS BEEN VERY INVOLVED IN THE INDUSTRY OF 3D IMAGING, which has given her access to technology that would otherwise be prohibitively expensive. Davies, who has a background in painting, has investigated the use of 3D imaging to create immersive environments that are completely computer generated and do not attempt to mimic reality. The realms she creates are more painterly and fantastic.

Davies's work is also very much about the invention of an interface that is closer to the body; like many others, she believes that the keyboard and screen are not necessarily the most "natural" means of accessing data, particularly when it comes to exploring art projects. Both *Osmose* (1995) and *Ephémère* (1998) are immersive realms that can be experienced firsthand by wearing goggles and a chest device that functions as a navigator, activated by body movements. Another way to approach the work is to watch the experience of another immersant, in real time. His or her choices affect what the other viewers see: the participant's physical experience of the virtual landscape is juxtaposed to a real-time projected rendering of what he or she is experiencing.

Unlike most virtual environments, Davies's works do not attempt to replicate a "real" landscape. Rather, one navigates a realm that takes its cue from the bodily impression of weightlessness, inspired by the artist's experience of diving. This dreamscape of sorts is generated in real time by a high-power processing engine, which makes each immersive trip a different experience. BW

DAVIES

AF

FOR

LIFE

CODE

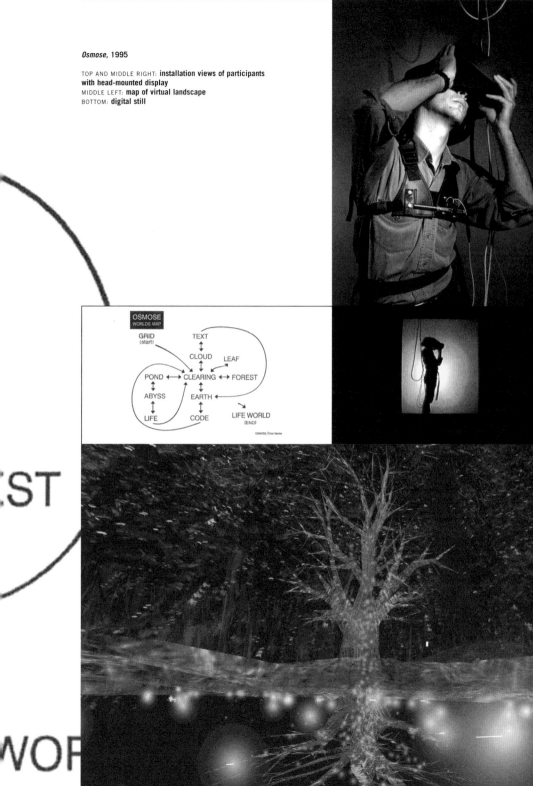

Osmose, 1995

TOP AND MIDDLE RIGHT: installation views of participants
with head-mounted display
MIDDLE LEFT: map of virtual landscape
BOTTOM: digital still

OSMOSE
WORLDS MAP

GRID (start)
TEXT
CLOUD
LEAF
POND — CLEARING — FOREST
ABYSS
EARTH
LIFE
CODE
LIFE WORLD (END)

OSMOSE/Char Davies

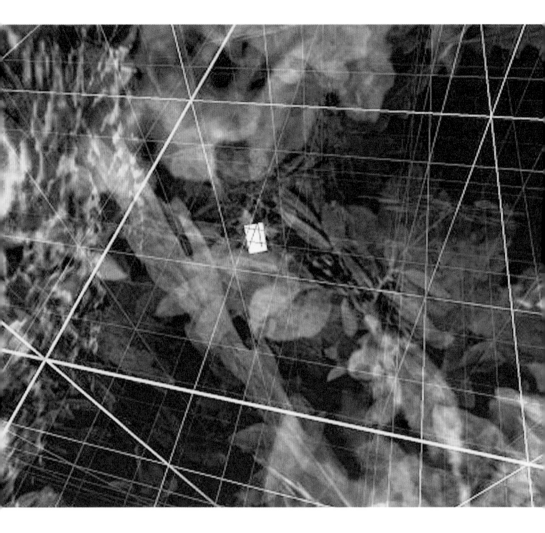

Osmose, 1995, digital still

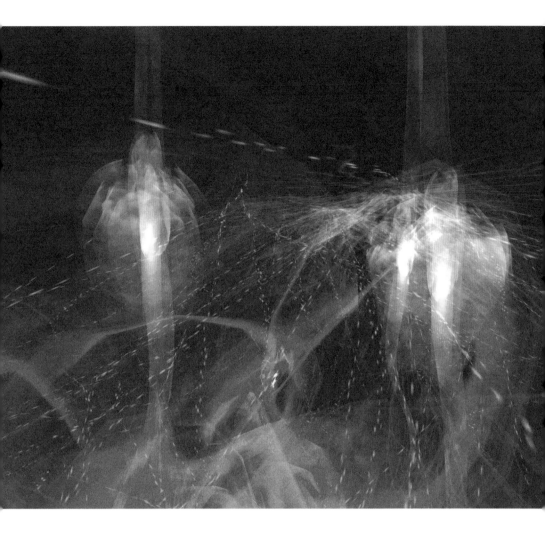

Ephémère, 1998, digital still

DÉCOSTERD

DÉCOSTERD & RAHM

THE SWISS ARCHITECTS DÉCOSTERD & RAHM ARE PART OF A NEW GENERATION that has engaged in a reexamination of the notion of architecture, seeing the built envirnoment as an interface for accessing and processing information experientially. The pair tend to operate at the intersection of technology, biology, and the mental construction of space. Their contribution to a recent public project, for instance, the *Roundup Vaccination Center* (2000), consisted of a botanical garden installed in a public park in Lausanne, whose purpose was to create and disseminate mutant organisms that are resistant to Monsanto's Roundup, the famous herbicide.

Melatonin Room (2001), the architects' project for this exhibition, is an example of what they refer to as "physiological architecture." Melatonin is a naturally occurring chemical produced by the human body. A high level of melatonin causes sleepiness; a low level produces alertness and a high energy level. *Melatonin Room* alternately offers an experience of stimulation, when the release of melatonin by the body is blocked by a high-intensity green light, followed by a calming effect, when the light diminishes in intensity and becomes ultraviolet, thereby increasing the body's production of melatonin.

Melatonin Room reflects upon the influence of biotechnology and the probable merging of architecture with science to create "intelligent" environments. This project, like the *Roundup Vaccination Center,* offers an interesting perspective on the evolving relationship of humankind to nature, conceived as a constantly redefined and manipulated environment. BW

RAHM

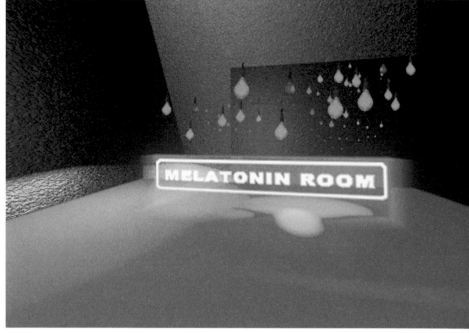

Melatonin Room, 2001, digital renderings

DROOG DESIGN IS A LOOSE COOPERATIVE OF DESIGNERS living and working in the Netherlands. Assembled by the critic Renny Ramakers and the designer Gijs Bakker, the group made its debut at the Milan Furniture Fair in 1993. Since then, this ever-changing assembly of furniture and industrial designers has created numerous products, projects, and spatial interventions all over the world. What ties their mass-produced products to their site-specific installations is an interest in how one can rethink or reuse preexistent materials and forms.

Against the call for the always new, Droog posits the wry, ironic (Droog means "dry" in Dutch), and often revelatory reassembly of what already is. The installation that they have created for *010101* calls attention to the fact that new technologies are not just science fiction artifacts or processes that will take us into uncharted terrain, insisting that they can and should act to intensify our experience of the existing world. By presenting products that make us aware of the relationship between how a computer sees or a mechanism behaves and our own reactions, Droog argues for the survival of the real in the age of the digital. The installation presents a new version of the domestic environment in which technology is revealed in its naked absurdity but also presented as an amusing and endearing toy. Art is not the new or the precious, Droog wants us to understand, but that which makes us aware of who and where we are. AB

IT IS PERHAPS IRONIC THAT THE COMMON THREAD uniting Brian Eno's entire artistic career is unpredictability. Visual artist, musician, composer, writer, and producer are just a few of the roles he has taken on over the past thirty years. Although he has gained recognition across the board, Eno is probably best known for being a founding member of Roxy Music; for his experimental collaborations with David Bowie, John Cale, Robert Fripp, and Nico; and for his role as the innovative producer of U2's critically acclaimed recent albums.

With the release of the album *Music for Airports* in 1978, Eno coined the term *ambient* to describe a particular genre of music for environments. At that time, he described ambient music as "suited to a wide variety of moods and atmospheres. . . . [It] must be able to accommodate many levels of listening attention without enforcing one in particular; it must be as ignorable as it is interesting."[1] Since then, Eno has continued to pursue this interest in the ambient in both his music and his installations.

It somehow makes more sense, for example, to think of his generative light and sound installations as atmospheres, rather than as tangible works of art. They include dim spaces, illuminated by color monitors and abstract projections, as well as lit rooms that rely purely on the integration of objects and sound to evoke a sense of a contemplative "quiet club."[2] In these infinitely mutating environments, the final combinations are left up to chance. An auditory landscape of Eno's compositions, often combined with electronically manipulated sound and language, fills the space. A software system or other generator of random sequences, however, makes the final decision regarding how to fit the pieces together within a certain set of parameters.

Once one allows the senses to engage the slowly evolving sound and visual elements of the environment, it almost seems possible to experience a keener level of perception of the surrounding space. Breath slows. Time seems to pause. The oasis of sound and light slowly develops into a meditative space or, as Eno describes it, a "form of musical painting."[3]

In essence, Eno's aesthetic is as multifaceted as the artist himself. One gets the suspicion that he could just as easily be referring to his eclectic life when he speaks of his sound, light, and video installations as generating "ever-new combinations," in which the same arrangement is rarely, if ever, heard twice.[4] KF

NOTES

1. Brian Eno, *A Year with Swollen Appendices* (London: Faber and Faber, 1996), 296.
2. Artist's statement, November 1999.
3. Ibid.
4. Ibid.

ENTROPY8ZUPER!

IN A BIOGRAPHY PROVIDED ON THE WEB SITE SHE CREATED WITH HER COLLABORATOR AND PARTNER, Michaël Samyn, Auriea Harvey of Entropy8Zuper! describes herself as a sculptor "who has traded her traditional tools for digital ones" and sees the Internet as "a vehicle for spreading a greater understanding of what is possible in this medium—Beauty, Communication, Emotion." Samyn describes himself as an "ex-artist" who formerly "produced many analog objects that nobody wanted." In 1995 he gave up sculpture for digital media. ("They take up less space.") Harvey and Samyn, who have been working collaboratively since 1999, have created a distinctive blend of images, music, and text, stitched together in meandering story lines that combine dramatic sights with cryptic plot twists.

Harvey and Samyn's major work to date is a three-part digital epic titled *Genesis, Exodus, Leviticus*, which loosely suggests a story of two lives intertwined (www.entropy8zuper.org). In fact, the artists met online, leading to an artistic collaboration that eventually developed into a full-blown romance. Previous online works such as *whispering windows* and *skinonskinonskin* charted the progress of their courtship with an emotional honesty that was surprising in its directness and potency. Harvey and Samyn have also pioneered a unique form of online live theater that they call *Wirefire*, which they perform in real time by manipulating layers of photographic images and sound. Like their Web pieces, *Wirefire* is unabashedly rich in image, texture, and sound.

There is a clear debt to cinema in the wide-screen format of their work and in the use of soundtracks to key emotional response. Saying he'd be making movies if it weren't for Hollywood, Samyn identifies his aesthetic goal as the fusion of art and entertainment in the creation of immersive works "as good as good novels." Photographic images, still and animated, are collaged together, floated on top of one another, slammed back and forth, and dissolved. Sections that function like computer games (as when visitors to *Exodus* are seemingly encouraged to blow up jumbo jets flying across the screen) give way to dramatically bleak landscape vistas, honeycomb structures holding pictures of the artists themselves, or images of tiny sheep hovering in a meadow. Butterflies flit across the screen, meet, and couple.

The feel of Harvey and Samyn's work is surreal rather than literal, and deliberately poetic rather than quotidian or analytical. The operative logic is that of a dream: things make sense, but in a way that is hard to pin down and articulate. The visually layered density of their collaborations makes the work of Entropy8Zuper! as satisfying on the tenth view as it was on the first encounter, if not more so, giving it a staying power that is rare in Internet-based art. JW

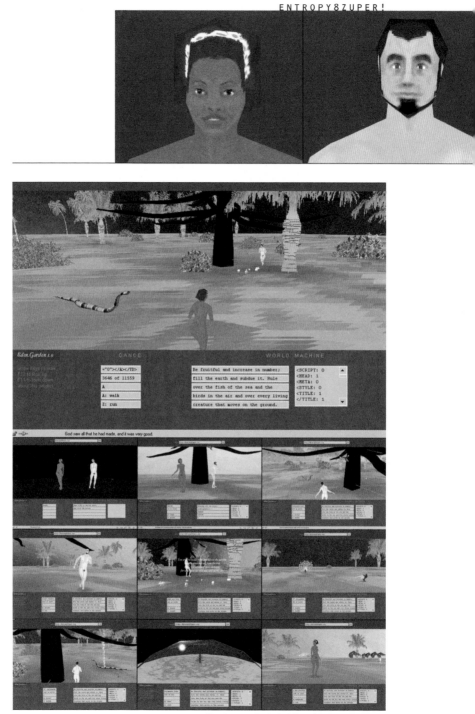

Eden.Garden 1.0, 2001, digital stills from Web site

It seems to me that
the modern painter
cannot express this
age, the airplane,
the atom bomb, the
radio, in the old
forms of the
Renaissance or of
any past culture.
Each age finds its
own technique.
**JACKSON POLLOCK,
1950**

IT SEEMS TO ME THAT THE MODERN PAINTER CANNOT EXPRESS THIS AGE,

THE AIRPLANE,
THE ATOM BOMB,
THE RADIO,
IN THE
OLD FORMS OF THE
RENAISSANCE
OR
OF ANY PAST
CULTURE.
EACH AGE FINDS
ITS OWN
TECHNIQUE.

OLD-FASHIONED FORMS IN NEWFANGLED TIMES

OR,

WHY WOULD ANYBODY IN THIS HIP AND MODERN WORLD BOTHER MAKING PAINTINGS?

JANET BISHOP

GIVEN THE HUGE CULTURAL SHIFTS OF LATE—
with so much contemporary human experience
funneled into the triangle between eye, keyboard,
and monitor—the continuing practice of painting
seems rather curious. Representations notwith-
standing, paintings are decidedly physical objects
that can exist alongside, but not within, the force
field of cyberspace. While technological advances
have made possible Jeremy Blake's digital works on
plasma screens (pp. 46–49) and Annette Begerow's
computer-driven projections (pp. 36–39), which are,
in compelling ways, *painterly,* such innovations have
not quelled the centuries-old desire to manipulate
wet pigment. Indeed the vast majority of paintings
are still made with a malleable medium, typically
oil or acrylic, which is applied to a more or less flat

Computers will prodigiously compose, paint, write and sculpt all day every day . . . forever. Oblivious to the debates surrounding origination, authorship, intentionality, and meaning, computers will pursue their creative objectives.
STEVEN R. HOLTZMAN, 1994

surface directly by a human being. As evidenced by the recent number of projects devoted to painting, this practice is not merely limping along, but thriving.

Throughout the last century, the predecessors of today's painters have actively engaged elements of other art media and mass media within the site of their canvases. Even before Georges Braque and Pablo Picasso started pasting newspaper clippings directly into their work in 1912, both artists replicated typographic characters or fragments from journals in their Cubist paintings. In his Pop works of the early 1960s, Roy Lichtenstein began using comics and advertising as sources for his imagery and palette. In a wry extension of the Cubists' fascination with the relationship between the mechanical and the handmade, Lichtenstein systematically applied benday dots, a printing artifact, across the surface of his paintings. This practice would become, ironically, the most individual feature of the artist's style—an allover pattern that would emphasize the flatness of his source material and, in turn, the various scenes pictured on his canvases. Andy Warhol, too, had a voracious appetite for ads as well as news images and the language of cinema. *National Velvet* (1963), for instance, is explicitly filmic. Upon a silver (screen) surface are dozens of images based on a still of the young Elizabeth Taylor, the blurred repetition suggesting passing frames of celluloid, the reality of the likeness facilitated by the technique of photo-silkscreen.

Ready access to hardware, software, Web sites, games, and an incomprehensibly vast amount of written and visual information via the Internet have all expanded the vocabulary of contemporary painting, often affecting both process and product. Chris Finley, for one, has worked extensively with the imagery and language of gaming—with flat, unmodulated colors and highly expressive subjects (pp. 76-77). He even stretches or scrambles his imagery to mimic the user's experience of waiting for computer-stored images to download into focus.[1] Kevin Appel's subjects are foremost architectural—hypothetical dwellings that are designed on the computer before being drawn or painted (pp. 28-29). Yet the overlapping planes of color in his current glass-house project resemble not only an imploded series of spaces but also the metaphoric layers or stacks on a computer monitor when more than one folder or file (window) is open at once. Within his futuristic landscape- or skyscape-like works, Adam Ross, too,

1. For a survey of relevant work, see RALF CHRISTOFORI, ed., *Colour Me Blind! Malerei in Zeiten von Computergame und Comic* (COLOGNE: BUCHHANDLUNG WALTHER KÖNIG, 1999).

Our society is measured by a cancerous growth of vision, measuring every-
thing by its ability to show or be shown and transmuting communication into
a visual journey.
**MICHEL DE
CERTEAU, 1984**

engages the multiple rectangles of standard interface design, each sug-
gesting a realm or even universe distinct from the next with virtual-reality
illusionism (pp. 122–23).

What hasn't changed much at all, however, is the physical reality of
the object. For artists like Finley or Appel, who make active use of the
computer as a sketchpad—an endlessly revisable medium for visual and
intellectual ideation—painting becomes an act of reclamation. As Lane
Relyea has noted, "The space of the monitor is neither physical nor
illusionistic, neither like a body nor an envelope; it's instead an
interstitial space, always between relaying input and feedback,
command and performance, facilitating the call and response of com-
munication."[2] A painting, however, is a consolidation of imagery, an
essentially decisive object made with particular materials handled in a
particular way. Surface has the capacity to carry the history of process;
scale might relate to the size of the monitor screen or paper tray but
doesn't have to. Whether it is shown publicly or not, a painting is an
intensely personal object. And whether or not its image is represented
elsewhere—in print, on TV, or on the Web—it is, in its most salient
form, a physical thing that exists in real time and in real space.

Paintings have the capacity to pose a different problem, capture a
different pleasure, engage our fantasies in a different way. As Dana Friis-
Hansen has stated, "There are few more sensuous materials with which
to make beautiful objects than paint."[3] As such, paintings stand apart
from the blur of images we see when we "surf." Well suited to eliciting
reflection, rather than consumption, they work a sort of magic, holding
a singular place within the pace of life now.

END

2.
LANE RELYEA,
"Virtually Formal,"
Artforum 37
(SEPTEMBER 1998): 133.

3.
DANA FRIIS-
HANSEN,
*Abstract Painting, Once
Removed* (HOUSTON:
CONTEMPORARY
ARTS MUSEUM,
1998), 18.

For contemporary
man the representa-
tion of reality by the
film is incomparably
more significant than
that of the painter,
since it offers,
precisely because of
the thoroughgoing
permeation of reality
with mechanical
equipment, an aspect
of reality which is
free of all equipment.
**WALTER BENJAMIN,
1936**

CHRIS FINLEY

CHRIS

THE WORK OF CHRIS FINLEY ACTUALIZES THE EXPERIENCE OF CYBERSPACE IN PHYSICAL TERMS, calling our attention to the compression of time and space characteristic of the digital realm and to the adjustments our senses have made in order to acclimate to this strange new environment.

Finley uses his computer to design a template for each painting he creates, and he actually incorporates the organization of computer programs into his own creative process. He notes that although programs such as Illustrator and Photoshop facilitate a certain amount of flexibility and creativity, the user is always constrained by a set of predetermined parameters. Following this model, Finley establishes a finite set of options (for color, shape, and form) before he begins a new design, and he adheres to these limitations throughout the process of composing the image.

Finley's paintings are large and bright, painted with the clarity and energy of sign graphics: crisp lines; glossy surfaces; clear, bright colors. He draws on a vast and varied visual vocabulary that includes hovering pizzas, oversized insects, bodybuilders, knife-wielding patriarchs, and society ladies. He freely combines these elements in startling juxtapositions and often skews the resulting image by stretching, cloning, or rotating portions of it, as one might do with basic image-manipulation software. Once he has finished a composition, he transfers the image from computer screen to canvas, carefully mixing each color to mimic the computer's palette. The relocation from virtual to physical space is never seamless, of course, but the signs of handcraftsmanship that shine through only make Finley's endeavor all the more meaningful. AG

FINLEY

Goo Goo Pow Wow, 2000–2001, digital template

RODNEY

RODNEY GRAHAM

IN THE LATE EIGHTEENTH CENTURY THE GERMAN PHYSICIAN FRANZ MESMER USED SOFT MUSIC, perfume, and beautiful objects to lull patients into a trancelike state. In the early twenty-first century Rodney Graham's hypnotic time-based installations clearly recall Mesmer's early investigations into the influence of ambiance and the power of the subconscious mind.

For more than twenty years Graham has maintained a consistent fascination with psychoanalytic theory and cyclical time, an interest that has perhaps reached its narcotic peak in his recent work. Graham's film and video installations endlessly repeat ambiguous narratives. They emphasize the stillness of silence and the persistence of sound. He engages the mind with paradoxical layers that are at once intelligent and absurd, tragic and lighthearted, monotonous and intoxicating.

In *Halcion Sleep* (1994), for example, the artist took a double dose of Halcion, a sedative reputed to elicit pleasant thoughts of the past. In this twenty-six-minute single-take video, we watch the pajama-clad artist sleep in the back of a van as it drives though the streets of Vancouver surrounded by "images of the engulfing urban environment reduced to coruscating 'city lights,' images that are intended to appear less as reality and more as a dream-projection or thought-balloon." [1]

Vexation Island (1997) again features the artist as oblivious protagonist. This time Graham bases his character on Robinson Crusoe, marooned on a tropical island. In this cycle, he is continually knocked unconscious by a falling coconut. It is a seamless loop of painterly daydream, at times frustrating in its repetition. Again and again Graham eventually comes to, unaware of his filmic past, only to be swiftly knocked out again.

In *Edge of a Wood* (1999), it is the viewer, rather than Graham, who becomes trapped in the loop. Upon entering the installation, we stumble upon a mysterious scene of an isolated field at night. A persistent helicopter searchlight beams through the pitch black that surrounds us. Yet each time the deafening roar of the chopper retreats from the scene, it returns again, unsatisfied with its last inspection of the wood. Is it looking for

GRAHAM

NOTES

1. Rodney Graham, "Siting Vexation Island," in *Island Thought: Canada XLVII Biennale di Venezia* (North York, Ontario: Art Gallery of York University, 1997), 13.

us or trying to find us? Are we watching or participating? The narrative is unclear. It is precisely that blurriness that keeps us there, however, curiously immersed in a search that never ends.

Rodney Graham aims not merely to lengthen time, but to suspend it. To some degree, it does not matter at which point one enters his installations, as they often seem to induce a feeling of being caught in the middle of things. It is a sensation that is at once alluring and irritating. But whether one likes it or not, the experience is nothing less than transfixing. KF

Edge of a Wood, 1999, installation view

ANDREAS GURSKY PRESENTS US WITH THE HYPERREAL. In his vast panoramas of spaces that have become generic in our global economy, he gives us what we think we know in a way we have never seen it before. These are neither the "God's-eye" views of nineteenth-century landscapes and architectural plans, nor intimate examinations of the character of things. In Gursky's photographs a new kind of space is made evident: the space of the new.

The artist achieves this effect by marrying a refinement of traditional photographic techniques with the new image-making possibilities afforded by digital technology. Trained by the German masters of realistic photography Bernd and Hilla Becher, Gursky knows how to fix what he observes through the lens onto paper with the precision of optics, the careful use of lighting, and the painstaking printing techniques that are proper to the technology invented almost two centuries ago. The artist also uses computer programs, however, which allow him to correct perspectival distortions, alter the proportions of the image, or synthesize multiple photographs into a single composition. Consequently, his images are as much products of digital code as impressions of light on photographic paper.

What Gursky gives us are images that gain a sense of totality through technology. Like his teachers and their great model, August Sander, the pre–World War II documenter of human "types," Gursky offers up objects that have no inside, no hidden nature. They are depictions of contemporary products and spaces in which all is immediately and seemingly evident. They portray things—whether they are buildings, objects, or people—that we can understand simply and absolutely as presented. This does not mean that these images are neutral. Gursky finds a grandeur in banal spaces of such structures as a hotel in Taipei (*Taipei*, 1999) and even in the rows of cheap merchandise displayed in *99 Cent* (1999). In the latter case, he underscores the pornography of the available by correcting the perspective and compressing the space so that the discount goods become overwhelming as they press against the picture plane. We cannot easily withdraw from either of these spaces.

Gursky makes us aware of the act of presentation itself, including all the choices and manipulations inherent in that act. These photographs do not represent anything so much as our own ability to make, even if the spaces or goods we create are utterly ordinary. And then they let us marvel at what we have made. AB

TOP:
99 Cent, 1999

BOTTOM:
Taipei, 1999

JOCHEM HENDRICKS

THE ORIGIN OF JOCHEM HENDRICKS'S *EYE* (2000) can be traced to the artist's longtime desire to "draw with my eyes."[1] To realize this goal, he began working in the early 1990s with equipment capable of scanning the motion of the eye. The process requires wearing a helmetlike scanner that records microscopic eye movements, which the scanner converts into data and outputs to a computer printer, resulting in a "drawing" that shows the path of the eye. Using this method, Hendricks has done eye drawings of a variety of subjects, ranging from small objects, the view from his window, faces, and pictures to immaterial visions such as "darkness," colors, and looking at "nothing."

In 1996 Hendricks's eye drawings culminated spectacularly in the creation of *Zeitung* (Newspaper), a piece representing the reading of an entire issue of the *Frankfurter Allgemeine Zeitung*, one of Germany's major daily newspapers. The data files recording Hendricks's reading of the *FAZ* were printed by the newspaper on its own presses, utilizing its normal format and paper stock. *Zeitung* was then shown and sold for a nominal price at the Frankfurt Museum of Modern Art and other institutions. For *010101*, Hendricks has created *Eye*, a new eye drawing charting the reading of the "Eye" entertainment calendar section of the *San Jose Mercury News*. The result is at once familiar and strange, a peculiarly linear abstraction of what is still recognizably an American newspaper magazine.

Speaking about his work, Hendricks has said: "What I am constantly searching for is the interface between myself and the world. And that is precisely what the 'Eye Drawings' are about."[2] Although created via a highly technological process, the eye drawings are about vision in a raw and unprocessed form. Hendricks seeks to eliminate the role of the hand in drawing, short-circuiting the traditional issue of "hand-eye" coordination in fine-art draftsmanship. His drawings offer a curiously literal and direct reflection of visual perception in action, preserving the peripatetic motion of the gaze as it peruses the world. Yet Hendricks's eye drawings also record a highly disciplined "seeing" that is more systematic and consciously governed than the natural human process of looking at the world. Indeed, his eye drawings, in their scratchy precision, point out how casually most people look at things, and how fleetingly. They emphasize the difference between looking carefully at something, or reading it from beginning to end, and merely passing one's eyes across its surface. JW

NOTES

1. Jochem Hendricks, conversation with the author, March 2000.
2. Interview with Jochem Hendricks, in *Augenzeichnungen*
(Saint Gall: Vexer, 1993), unpaginated.

ABOVE: **Artist with head-mounted eye scanner**

RIGHT: *Hand (rechtes Auge)* (Hand [right eye]), 1992

BELOW: **Plotting equipment used to create eye drawings**

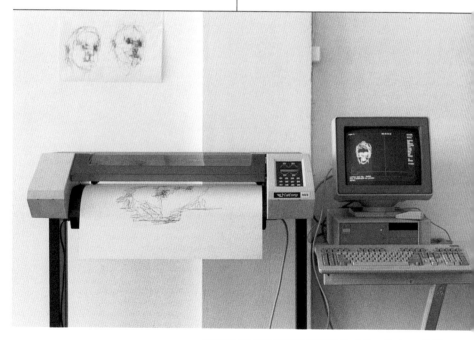

OVERLEAF: *Eye,* 2000, test scans for front page (left) and back page (right)

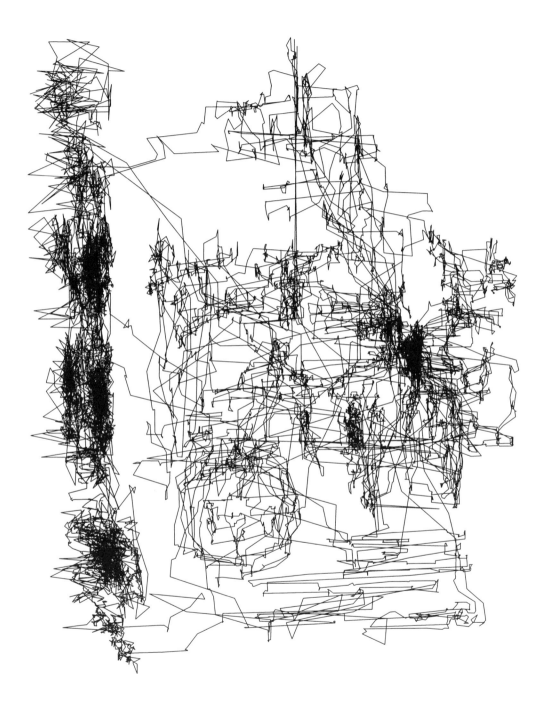

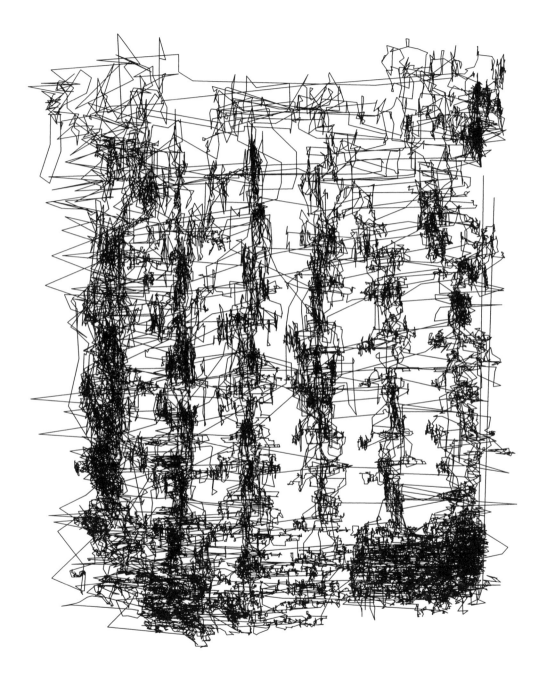

HU

HU JIE MING

ACOLYTES OF THE INTERNET CULTURE HAVE PROMISED THAT THE WORLD WIDE WEB WILL BRIDGE CULTURAL CHASMS that have existed for centuries, leveling the rocky terrain of the world's cultures to create a homier "global village." Shanghai-based artist Hu Jie Ming has spent the past five years exploring the deeper realities of a cultural vertigo that emerges when a China that is increasingly open to Western ideals is wired to a West that is increasingly enchanted by the surface details of Eastern culture.

Hu's primary mode of expression has been through video installations. In 1996 he created *New Journey to the West*, a video whose narrative reflects the conflicting pressures felt by the Chinese in their relations with the Western world. This video allegorically examines the feeling of obligation to look to Western culture for cues on technological and commercial advancement (as well as for direction in contemporary art), while still wishing to preserve spiritual and cultural traditions unique to China.

In *The Fiction between 1999 & 2000* (2000), Hu Jie Ming takes on a more universal challenge, the daunting proliferation of media and information engendered by the Internet. Hu's huge information labyrinth is constructed from screen captures collected from across the Web and network television during the twenty-four-hour period from midnight of December 31, 1999, to midnight of January 1, 2000. It represents the diffi-culties we all face in navigating through a world where information can be empowering, but only if we can filter through the barrage of useless images and texts that cloud our minds and dull our instincts. Hu asks, "What will we choose to do when we are controlled by information and lose ourselves?" AG

JIE MING

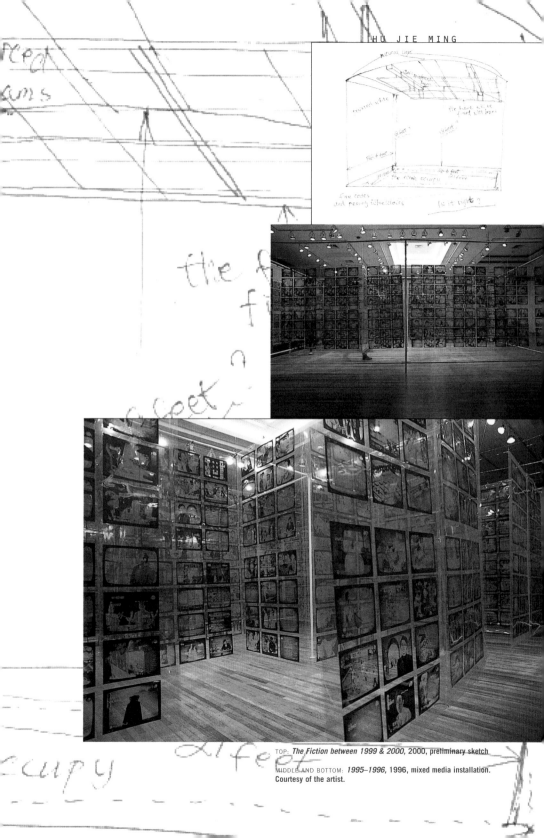

TOP: *The Fiction between 1999 & 2000*, 2000, preliminary sketch

MIDDLE AND BOTTOM: *1995–1996*, 1996, mixed media installation.
Courtesy of the artist.

VIRTUALITY IS THE CULTURAL PERCEPTION THAT MATERIAL OBJECTS ARE INTERPENETRATED BY INFORMATION PATTERNS.

Virtuality is the cultural perception that material objects are interpenetrated by information patterns. **N. KATHERINE HAYLES, 1999**

STEP INTO THE FRAME

KATHLEEN FORDE

IT IS 1896, AND MEMBERS OF A SHOCKED MOVIE AU-
DIENCE, unaccustomed to the illusion of real space
on film, are running out of the theater, fleeing a
train they believe to be rushing toward them from
the screen. In 1960 Sensorama uses film loops,
scent, and a vibrating seat to re-create a motorcycle
ride through New York City—pizza, potholes, and
all. And in the year 2001 a museum visitor floats
through virtual environments created by artist
Char Davies using a stereoscopic head-mounted
display, interactive 3D sound, and an interface based
on breath and balance (pp. 62–65).

Artists have attempted to create the illusion of distance and depth on a flat surface since the early fifteenth century. Realities other than the tangible world we live in (the present) have existed since the beginning of time. In essence, what defines human consciousness is the ability to imagine other "realities," starting with the cognitive awareness of past and future. It can be argued then that, conceptually, virtual reality—and by this I mean technology that purely simulates tangible space—is not news. Useful? Yes. Seductive? Of course. But, in and of itself, virtual reality is simply a technological incarnation of a timeless idea.

Having said that, the aforementioned virtual environments by Davies are indicative of a pushing forward of the concept of virtual reality as an artistic medium. By using the illusion of 3D space in a manner that does not merely mimic the world in which we live, Davies creates imaginary landscapes unlike anything that our senses are used to perceiving. It is precisely the unreal quality of these solitary spaces that allows the work to be psychologically transformative on some level for the viewer (or, in Davies's words, the "immersant").

Davies's efforts to induce a heightened conceptual awareness of our "ways of seeing" are reflective of another, related current in contemporary art—one that I will hereafter refer to as immersive art—which attempts to go beyond the bells and whistles of new technology. By definition, immersion is sensory interaction and therefore, like the proverbial tree falling in a forest, cannot be apprehended without a viewer. It is in fact our psychological and, at times, physical response to a space without concrete boundaries that reflects the blurry lot of contemporary society. Spaces of immersion function as a new artistic language that posits the viewer's experience as an art object by addressing the processes of perception. By recognizing the collapse of psychological and physical space, this work investigates the only reality that we can define—a fluid mix of mental space and physical interface.

One artist whose work exemplifies this trend is Gary Hill, a multimedia artist who frequently explores the cognitive process in his artwork. Upon entering his installation *Storyteller's Room* (1998), the viewer walks into a black void, a room so dark that it is impossible to determine the form and dimensions of the space, or even discern the presence of other visitors.[1] At irregular intervals a strobe light flashes for an instant. The brief bursts of illumination allow one to catch only

The closest analog to Virtual Reality in my experience is psychedelic, and in fact cyberspace is already crawling with delighted acid-heads. **JOHN BARLOW, 1990**

The psychological basis of the metropolitan type of individuality consists in the intensification of nervous stimulation which results from the swift and uninterrupted change of outer and inner stimuli. **GEORG SIMMEL, 1902**

1. For *Storyteller's Room,* see
http://www.donaldyoung.com/garyh.htm.

THE MOST PROFOUND CHANGE

USHERED IN BY THE DIGITAL REVOLUTION WILL NOT INVOLVE BELLS AND WHISTLES OR NEW PROGRAMMING TRICKS. IT WILL NOT COME IN THE FORM OF A 3-D WEB BROWSER OR VOICE RECOGNITION OR ARTIFICIAL TECHNOLOGY. THE MOST PROFOUND CHANGE WILL BE WITH OUR OWN GENERIC EXPECTATIONS ABOUT THE INTERFACE ITSELF. WE WILL COME TO THINK OF INTERFACE DESIGN AS A KIND OF ART FORM—PERHAPS THE ART FORM OF THE NEXT CENTURY.

The most profound change ushered in by the digital revolution will not involve bells and whistles or new programming tricks. It will not come in the form of a 3-D Web browser or voice recognition or artificial technology. The most profound change will be with our own generic expectations about the interface itself. We will come to think of interface design as a kind of art form—perhaps the art form of the next century. **STEVEN JOHNSON, 1997**

fleeting glimpses of the physical surroundings. Was it a column or another visitor? A lit wall or a projected image? A shadow? It is hard to be sure whether we are remembering correctly what we thought we experienced a moment ago. Once one's eyes have adjusted to the darkness, the flashes of light can be identified as projected images that quickly fade to black. Representations of city streets, passing cars, and old buildings fit so surely within the architecture of the space that the walls seem to dissolve into transient windows on an outside world. Yet what we see and what we recall quickly collapse into a memory in the dark—a memory that we can never be certain is not colored by our own mind's eye. In a sense, this is the conceptual art of the new millennium—art that affects our perception and challenges our standard modes of processing information. Its core is firmly rooted in making us aware of the hazy juncture of a physical world and a space that is more psychological or imagined.

Tatsuo Miyajima's work also often functions in a manner that invites us to question our sensory experiences. In Miyajima's *Floating Time* (2000; pp. 6, 104–5), as in Hill's installation, the viewer is plunged into a darkened space. The only thing the eye can make out is digits projected randomly through space. We have a sense that the blackness goes on forever, that we are immersed in a sea of numbers. It is a slippery sense of destabilization that gently urges us to come to terms with our own physiological reactions to intangible spaces of electronic data. In this way, Miyajima invites the viewer to engage the blurry residue of recent technological developments.

These artworks are symptomatic of one of the defining features of the contemporary cultural landscape: the constant intersection of the material and immaterial, as manifested in virtual gaming, online communities, Imax films, simulators, DVD projections, and surround-sound installations. Turn the projection off, disconnect the cable, unplug the game, and what remains? An empty room, a blank screen, a memory of how it felt to be within that three-dimensional place where a wider existence was inferred. Yet we still have our subjective experience, a psychological reality that is arguably just as valid as any other. The technology used in immersive environments merely sets the stage for digital mediation in tangible space. It is then up to us to engage that space physically and psychologically. This is our reality.

He'd operated on an almost permanent adrenaline high, a byproduct of youth and proficiency, jacked into a custom cyberspace deck that projected his disembodied consciousness into the consensual hallucination that was the matrix.
WILLIAM GIBSON, 1984

In a slightly different way, *Melatonin Room* (2001; pp. 66–67), an installation by the Swiss architects Décosterd & Rahm, also explores the relationship among the tools of technology, the body, and the mind. In this piece, the artists actually affect metabolism by way of lights that provoke sensations of lethargy or energy. With this environment, immersive art has been taken to its interactive extreme. The artwork is not a physical object in this case, but purely a dialogue between technology and the body. In our everyday lives, it has become second nature for us to accept this intersection. Ultimately Décosterd & Rahm have produced a space that, when engaged by the physical and mental body, reflects recent technology's influence on the permeability of the conscious mind.

A constant stream of intangible thoughts and images, initiated by interfaces of technology, flows through our minds all day, every day, for a lifetime. The art of immersion explores just that interface. Contemporary living has become a hyperreal experience in which one can never be sure what defines reality and whether or not this even matters. Recent technological developments have forced us to confront these definitions. Quite simply, immersive spaces are an expressive medium that observes day-to-day life in a way that is somehow meaningful or even beautiful. The purpose, however, is the same as it has been throughout the history of art—to recognize and, at the same time, transcend the social context in which we live. Ultimately this art of immersion, of the senses, is simply an aesthetic reflection of the sometimes conscious, sometimes deliberate, but always willful way in which we create our own realities every day.

Our technologies and our fictions are converging.
TIMOTHY DRUCKREY, 1994

END

CRAIG

CRAIG KALPAKJIAN

CRAIG KALPAKJIAN MAKES US SEE THE BEAUTY IN THE BANAL. His work concentrates on details of office interiors we usually never notice: lay-in ceilings; fluorescent lighting fixtures; and the corner where linoleum, white semigloss paint, and a plastic baseboard meet. Within these small details, he finds landscapes of heroic proportion and eerie abstraction. In *Corridor* (1995), he has chosen to animate this world of almost nothing. We find ourselves traveling down an endless corridor that is slightly curved, evenly lit, and without a clear end. Only fire alarms and lighting fixtures measure our progress. Of course, such perfection is not possible in the real world; Kalpakjian's environments are created entirely on the computer. Every detail of *Corridor,* from the texture of the paint to the slight reflections on each surface, is the result of programming, not the hammering of nails or the wielding of a paintbrush.

What Kalpakjian reveals in this manner is the complete artificiality of the environments we inhabit, and their distance from our human experience. The surfaces that surround us are the result of chemical processes (since they are almost all made out of synthetic or plastic materials); building codes that are meant to protect us from danger, whether of fire or of falling; and economic considerations that leach out any unnecessary detail. In Kalpakjian's hands, the economy and logic of computer code reveal this condition. It is also worth noting that *Corridor* resembles the interior of a canonical piece of modernist architecture produced for the newly rational state bureaucracy: Walter Gropius's 1927–29 Social Welfare Office in Dessau, Germany. Kalpakjian thus also reminds us of the emptiness at the heart of modern architecture—not only its daily reality but also its idealistic beliefs in rationality and perfect form. AB

KALPAKJIAN

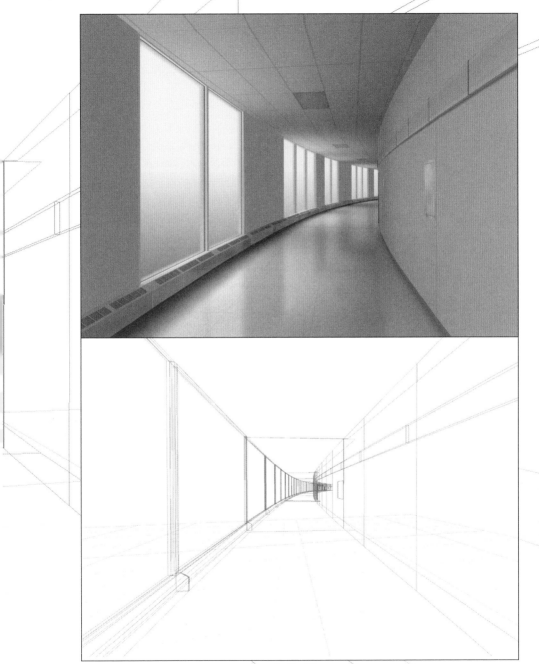

Corridor, 1995

TOP: **digital video still**
BOTTOM: **wire-frame rendering**

LEE

THROUGHOUT HER CAREER LEE BUL HAS USED HER WORK TO EXPLORE DISCOURSES OF GEN-DER AND SEXUALITY, focusing her inquiries on the cultural production of the body. Her early performances often incorporated "soft sculptures," worn as extensions of her own form. They were staged on city streets as a means of transgressing the traditional con-texts of artistic production and presenting her critique to a larger public.

Though her more recent work takes the form of static sculpture, it extends her ex-ploration of the sociocultural processes through which gender stereotypes and constructs are generated and institutionalized. Her Cyborg series builds on imagery borrowed from Japanese *anime,* a pop culture phenomenon that has been hugely successful in her native Korea. The female superheroes depicted in these animated videos are quintessential male fantasy figures, ultrafeminine in appearance and controlled by men, but at the same time powerful and capable of extreme violence. Lee's Cyborgs sport the tiny waists and huge breasts of these characters but are missing heads, organs, and limbs; they are incomplete, unstable bodies. Further, Lee casts her Cyborgs in silicone, the material used by the med-ical technology industry to craft extensions or substitutions for human body parts. She simultaneously questions the literal and visual production of female bodies for male con-sumption and the ostensibly neutral technologies that enable such production.

Still more recently, Lee has begun a series of sculptures that seem to trump the gen-der issues raised by her earlier works. *Supernova* (2000), an immense hanging creature crafted of cool white polyurethane, is rewardingly difficult to classify. This gnarled, twisting form writhes with tendrils that resemble roots or tentacles but extend outward from smooth plates similar to the armor of the Cyborgs. This is a posthuman body, tran-scending the dichotomies between nature and artifice, male and female. It is at once glor-ious and sinister, familiar and alien, grotesque and strangely seductive, and it beckons us toward a sci-fi future in which species identity renders gender identity irrelevant. AG

BUL

Supernova, 2000

EVERYTHING HAPPENS AT ONCE...
NOWNESS/ACTUALITY/HALLUCINATION/IMAGINATION.[1]

EUAN

EUAN MACDONALD

LIKE MOST OF EUAN MACDONALD'S WORK, THE VIDEO PIECE *TWO PLANES* (1998) IS DECEP-
TIVELY SIMPLE. A pair of passenger carriers, one upon the other, fly slowly through a
clear sky over the course of the three-and-a-half-minute loop. The imagery somehow
feels comfortable and familiar yet requires a rationale, and we are left to conclude that
what is on the screen before us is not only improbable but also impossible. Because the
imagery retains a certain realness, however, it challenges the nature of video as a docu-
mentary medium in its own subtle way. On a fundamental level, *Two Planes* makes clear
that we cannot trust what we see.

More prolific in drawing than in time-based work, Macdonald uses the medium of
video like a pencil or pen—that is, as a way of realizing visual ideas in visual form. The
vision articulated in *Two Planes* was inspired by a scene of a mid-flight fuel exchange
between two U.S. Air Force jets in the 1964 film *Dr. Strangelove*. After recording one
plane in the sky, the artist had the footage digitally altered, duplicating the first plane
to give it a mate, thus creating this odd metaphor for human coupling. Our experience of
the piece as viewers is critical to Macdonald. Just as live television reporting creates a
situation of simultaneity between the actual scene and the person sitting on the couch in
front of the screen, Macdonald's imagery on the monitor engages our own fantasy lives,
pulling our imagination into a daydreamlike state.

Macdonald's most recent work, *3 Trucks* (2000), further explores notions of
simultaneity through a staged scenario of ice-cream trucks slowly approaching a remote
intersection. Like *Two Planes*, the piece presents an unlikely convergence of anthropo-
morphized vehicles, though in this case the footage is visually unmanipulated. The audio
is amped up, however, so that the sound of this particular vending vehicle, which is
usually both eerie and appealing, becomes chaotic and confusing. The piece toys with
narrative but remains open-ended, resisting any variable conclusion. JB

MACDONALD

NOTES
1. Euan Macdonald, on a series of short videos in development
based on the technological effects of timing and simultaneity
(fax to Adrienne Gagnon, 5 June 2000).

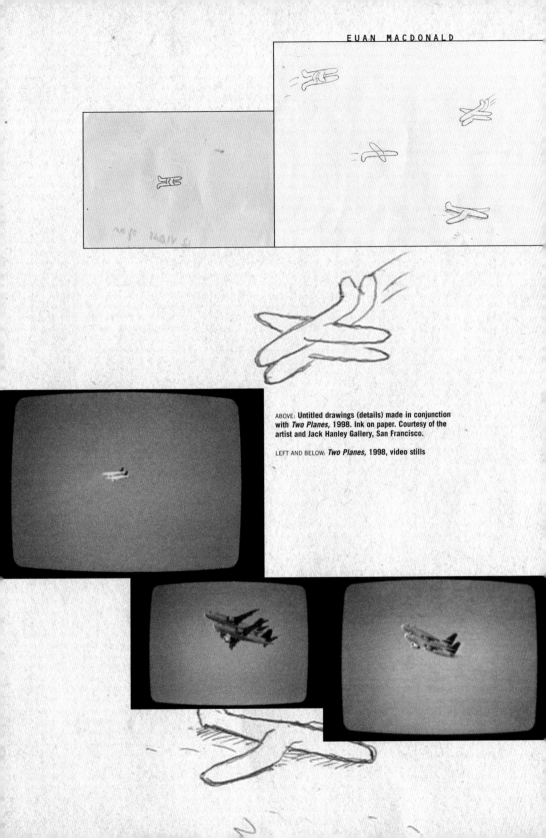

ABOVE: **Untitled drawings (details) made in conjunction with *Two Planes*, 1998. Ink on paper. Courtesy of the artist and Jack Hanley Gallery, San Francisco.**

LEFT AND BELOW: ***Two Planes,* 1998, video stills**

JOHN
MAEDA

TAP TYPE WRITE (1998) IS A USELESS EXERCISE IN PURE TYPOGRAPHIC FUN. It also happens to realize many of the dreams of modernist graphic designers who sought to capture the energy of the machine age in typography. John Maeda, a computer engineer and graphic designer working at MIT, claims that he started developing the series of experiments that led up to *Tap Type Write* in order to please his young daughters. Whenever he was working on the computer, they wanted to play with the keyboard, so he programmed his Macintosh so that something unexpected would happen when they touched the keys: letters would fly, somersault, grow, pulsate, and perform a circus full of acrobatics on the screen. These delightful acts of typographic daring create patterns that change over time. They can express moods or remain purely abstract. They have no particular function. To Maeda, however, they point to the potential of using the computer as a tool for making beauty.

Raised in both the United States and Japan, Maeda trained in the U.S. as an engineer and then in Japan as a designer. He believes that only if an artist understands the code of a computer as a painter understands paint and the paintbrush can she or he produce what we might think of as art. *Tap Type Write* is inspired by some of the great typographic experiments of the modernist era. In many designs by masters such as Jan Tschichold and Paul Rand, the designers were seeking to push letters beyond their supposedly neutral position as carriers of meaning to reveal their nature as marks of a particular technology. They also wanted to make designs that responded to the speed and distraction that were typical of the way in which modern people read. In *Tap Type Write*, Maeda has managed to translate their dreams into the digital age. Perhaps his experiment will have a use: it might lead us to dance with our letters as we write them, thus choreographing a breakdown of the difference between meaning and its appearance, which is already only as deep as the computer screen. AB

Tap Type Write, 1998

THIS PAGE AND OVERLEAF: digital stills
BACKGROUND: preliminary sketches

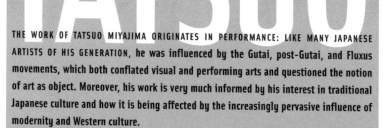

THE WORK OF TATSUO MIYAJIMA ORIGINATES IN PERFORMANCE: LIKE MANY JAPANESE ARTISTS OF HIS GENERATION, he was influenced by the Gutai, post-Gutai, and Fluxus movements, which both conflated visual and performing arts and questioned the notion of art as object. Moreover, his work is very much informed by his interest in traditional Japanese culture and how it is being affected by the increasingly pervasive influence of modernity and Western culture.

How tradition and modernity coexist and adapt to each other is, in Miyajima's view, epitomized by our relationship to time in various cultural contexts. Time is an interesting vehicle for tracing the evolution of culture: while counting and measuring may be shared concepts—and the instruments used for counting, universal—the meaning of time varies greatly from one part of the world to another. LED counters, which have become ubiquitous in urban environments all over the globe, reflect the uniformity of time in postindustrial societies; they formally represent the acceleration of cultural integration resulting from technological advances as well as from the increase in travel and exchanges of all kinds.

Miyajima refers to time in relation to the traditional Japanese concept of *shakkei*, which literally translates as "borrowed scenery." It describes the Zen gardener's relationship to the landscape that surrounds his garden, as he adjusts the landscape he controls to make it harmonious with the one he can only contemplate. *Floating Time* (2000) randomly projects the time in a dark space, which is literally illuminated by the flashing digits, with the position of the projection changing as time passes. This results in an immersive experience, a space to reflect upon our relationship to the passing of time, as well as the notion of time as a universally shared landscape to which we constantly need to adjust. BW

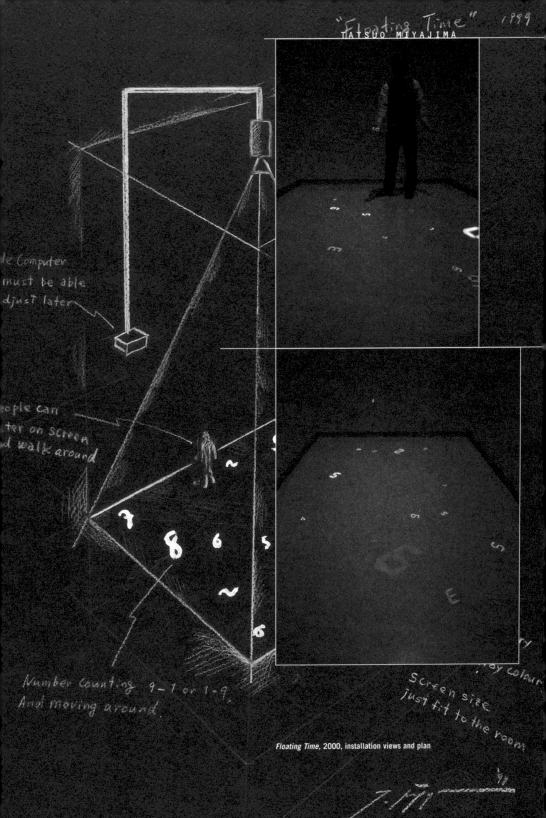

"Floating Time" 1999
TATSUO MIYAJIMA

le Computer
must be able
djust later

ople can
ter on screen
d walk around

Number Counting 9–1 or 1–9,
And moving around.

Screen size
just fit to the room

colour

Floating Time, 2000, installation views and plan

I REALIZED THE PLACE WAS AWASH IN NOISE. THE TONELESS SYSTEMS, THE JANGLE AND SKID OF CARTS, THE LOUDSPEAKER AND COFFEE-MAKING MACHINES, THE CRIES OF CHILDREN. AND OVER IT ALL, OR UNDER IT ALL, A DULL AND UNLOCATABLE ROAR, AS OF SOME FORM OF SWARMING LIFE JUST OUTSIDE THE RANGE OF HUMAN APPREHENSION.

I realized the place was awash in noise. The toneless systems, the jangle and skid of carts, the loudspeaker and coffee-making machines, the cries of children. And over it all, or under it all, a dull and unlocatable roar, as of some form of swarming life just outside the range of human apprehension. **DON DELILLO, 1985**

A LEAST EVENT

DAVID TOOP

AT THE VERY BEGINNING OF THE 1970s I ATTENDED weekly workshops taught by the late John Stevens, a drummer whose intuitive dissection of the improvisation process had led him to devise a collection of illuminating exercises useful to novice musicians such as myself as well as seasoned professionals. A pioneer of European free jazz, Stevens understood that most musicians desperately want to play. Their desire to make sound, he realized, tended to undermine the ideals of cooperation and mutual listening that lie at the heart of spontaneous music. So one pivotal composition, entitled "Click Piece," instructed the players to make the shortest

sound possible on their instruments. At its best, the resulting piece was like bursts of colored light imprinting a transient tattoo on the silence out of which it emerged.

At roughly the same time, I discovered the NOIT drawings of artist John Latham. Minimal blasts of black spray paint on untreated canvas, these instant drawings declared the cosmological importance of a "least event" in Latham's personal crusade to prioritize time over space. Such important landmarks of reductionism as these seem to have grown in significance as we move into the digital domain. As with many other examples of twentieth-century art and music, the restriction or temporary absenting of an identifiable human signature was seen as a necessary transition toward new conditions.

Now more than ever, music can no longer be assessed using conventional criteria, even though its impact is still subject to human desires and the formulations of human biology and neurology. Traditionally, music is associated with place, a moment in time, human activation, the unfolding and completion of a sequence. This is true even of "4′ 33″," John Cage's so-called silent piece from 1952, in which the timed activation of inactivity, or silence, heightens a listener's sense of being in one place for a specific duration and intensifies his or her perception of that locus.

But as digitization progresses like an eraser, rubbing out more and more solidity and replacing it with intangible communications and symbolic objects, music becomes less susceptible to this geographical grounding. The tendency to locate some part of music's character within a place of origin, a legendary live performance, or some unique aspect of the creator's human identity is becoming an anachronism. Where, for example, does the music exist if it can be accessed only through the Internet? Or in which space is it created if no physical space (other than a computer screen) or conventional sound-generating tools are used in its construction? Is there an author? Is there a subject? After remix culture and interactivity, is the work closed at any point in time or permanently open? How do we describe free software that allows us to modify the programmer's music? Is there any point in describing certain sound-related activities as music?

With roots in the pre–World War I machine noise of the Italian Futurists, sound art presupposes a sound world in which humans

The radio would be the finest possible communication apparatus in public life, a vast network of pipes. That is to say, it would be it if it knew how to receive as well as to transmit, how to let the listener speak as well as hear, how to bring him into a relationship instead of isolating him. On this principle the radio should step out of the supply business and organize its listeners as suppliers. **BERTOLT BRECHT,** **C.1926**

simply devise or initiate the conditions of a musical event. For the Futurists, there was a unique excitement in the sensation that machines were gaining control in the face of human weakness. The rich new sounds emitted by machines were evidence of their ascendant life force. These sounds occurred in physical spaces such as battlefields and urban streets. Digital assemblage, by contrast, is a process of building sound from scratch in the digital domain or transferring audio events from physical to virtual space where transmutation becomes possible. *Constructions I–IV,* for example, a CD release by the London-based composer John Wall, creates dramatic and seamless digital matches between Wall's acoustic recordings of instrumental improvisations—a cello, a clarinet, a trumpet, and so on—and sampled fragments of the work of composers and musicians such as Evan Parker, Ryoji Ikeda, and Harrison Birtwistle.[1] Many dissimilar acoustic spaces, times, and points of cultural reference are brought together within the virtual space of Wall's computer.

1.
JOHN WALL,
Constructions I–IV,
Utterpsalm, 1999.

For digital audio specialists such as Markus Popp of Oval, Christophe Charles, and Terre Thaemlitz, the processing of existing material represents opportunities for radical social recontextualization. Thaemlitz's "Resistance to Change" filters and resynthesizes Billy Joel's "I Love You Just the Way You Are," using the message and nostalgic aura of the song as a way of addressing what Thaemlitz describes in his liner notes for the recording as "fears of cultural loss."[2] One object of this sense of cultural loss may be the transitional nature of music itself. Many of the products of digital process are conceived as an assault on the hierarchical structures of the music industry—its methods of distribution, its legal framework of ownership, its romantic notion of the composer.

2.
TERRE
THAEMLITZ,
means from an end,
Mille Plateaux
MP CD 44, 1998.

As with the 1970s methods of Stevens and Latham, digital techniques for creating a new view of humanness can be interpreted as somehow inhuman in their efforts to circumvent stereotypical gestures of expressionism. The minimalist digital recordings of musicians such as Ryoji Ikeda, Thomas Brinkmann, and Bernhard Günter have been described as microscopic sound. Initially envisaged as a perfect audio environment that solved the problems of unreliability and unwanted noise associated with analog recording, the digital domain has revealed itself to be subject to many glitches of its own. The subversion of the supposed perfection of digital sound, along with new approaches to the

I much prefer this new system whereby a computerized voice rather than the operator gives you the number you want. The sound of long-distance interference on the phone, or static on the car radio, is, to me, reassuring, sensuous, even beautiful. **DAVID SHIELDS, 1996**

phenomenology of silence, noise, and the least event that constitutes a musical composition, installation, or audio performance were the first steps in defining digital music as a departure from analog methods.

Despite this radical development, both the desire to democratize music making and the compulsion to explore sound at microscopic levels are echoes of improvisation exercises such as "Click Piece." Whereas improvised music was, and is, a collective social activity that found its meaning in public performance, digital technology encourages solipsism. In the near future, it seems that many of the most interesting developments in this field will come from audio artists who struggle to resolve difficult issues of performance and collaboration, traditional practices that continue to exert a compulsive attraction in the digital landscape of the twenty-first century.

END

AN ACID TRIP,

A NEW CYBERPUNK NOVEL, A QUICK-CUT MTV VIDEO, OR A NIGHT AT THE "HOUSE MUSIC" CLUB CAN PROVIDE THE SAME HYPERTEXT-STYLE EXPERIENCE. THE RULES OF LINEAR REALITY NO LONGER APPLY.

MEANWHILE, AS EVIDENCED BY QUANTUM PHYSICS AND CHAOS MATH, NUMBERS AND PARTICLES HAVE CEASED TO BEHAVE WITH THE PREDICTABILITY OF LINEAR EQUATIONS. INSTEAD THEY JUMP AROUND IN A DISCONTINUOUS FASHION, DISAPPEARING, REAPPEARING, SUDDENLY GAINING AND LOSING ENERGY. OUR REALITY, SCIENTISTS ARE CONCLUDING, CAN NO LONGER BE EXPLAINED BY THE SIMPLE, PHYSICAL, TIME-BASED RULES OF LAW AND ORDER.

An acid trip, a new cyberpunk novel, a quick-cut MTV video, or a night at the "house music" club can provide the same hypertext-style experience. The rules of linear reality no longer apply. Meanwhile, as evidenced by quantum physics and chaos math, numbers and particles have ceased to behave with the predictability of linear equations. Instead they jump around in a discontinuous fashion, disappearing, reappearing, suddenly gaining and losing energy. Our reality, scientists are concluding, can no longer be explained by the simple, physical, time-based rules of law and order. **DOUGLAS RUSHKOFF, 1994**

MARK

MARK NAPIER'S WEB SITE *POTATOLAND*, which brings together all of the online projects the artist has produced since 1995, has become one of the key examples of online art experiments. Napier first became known for an interesting online project based on the Barbie doll, which caused a stir when Mattel (Barbie's manufacturer) threatened to sue if he would not remove the offending Web pages from the Internet. He has subsequently reoriented his research, focusing on the conditions of online viewing and the blurring notions of tool and content.

Potatoland includes projects such as the *Web Shredder*, an in-browser device that both reveals and undermines the hierarchy and order established by code as it redisplays any Web page selected by the user while totally ignoring the HTML tags, resulting in a somewhat exhilarating chaos. This work epitomizes Napier's relationship to the network, which he treats like a landscape. In fact, the artist considers the *Shredder* to be an integral part of another project, the *Digital Landfill,* which treats the overwhelming flow of data as potential info-garbage in need of recycling. What one person no longer needs may be useful to another. What may seem old to one user may be news to the next. Of course, the list of URLs in the *Digital Landfill* is also very telling.

The net-scape is an environment that, more than any other, is fashioned by the way data is accessed or ignored. Representation naturally takes its cue from the network itself; hence it is crucial that Napier's work be experienced online, with the larger, undefined context of the Web around it. *Feed* (2001) continues this exploration of data processing or, as Napier puts it, "data consuming." In that sense it is an anti-browser, an ambient rendering of data noise. BW

NAPIER

Feed, 2001

RIGHT: **preliminary sketch**
BELOW AND OVERLEAF: **digital stills from Web site**

ANIMATES OBSERV
VER ANIMATES
DISPLAYS

SEE

RCE

VISIB

THE BODY OF WORK ROXY PAINE HAS PRODUCED OVER THE LAST FIVE YEARS is often noted for its wild diversity. In 1997 he created both *Psilocybe Cubensis Field,* a field of twenty-two hundred meticulously handcrafted replicas of mushrooms scattered across a gallery floor, and *Paint Dipper,* a machine that creates minimalist paintings by successively dipping freshly stretched canvases into a basin of white paint, until layers of encrusted paint hang heavy along their bases. Nineteen ninety-eight brought *Crop,* a display of dozens of gorgeously replicated poppies clinging to a patch of dirt, and the first *SCUMAK (Auto Sculpture Maker),* a computer-programmed machine that produces small, amorphous sculptures by extruding polyethylene at various speeds and frequencies.

Despite the apparent incongruity of his subjects, Paine's entire body of work seems to address the limitations of creative production. With a wry and subtle humor, he systematically dispels the myth of the transcendent artist. The fields of mushrooms and poppies might be said to represent chemically assisted creativity. Psilocybic mushrooms are powerful hallucinogens, and poppy pods are the source of opium; both are strong narcotics believed to induce heightened states of creativity and have been used and abused by generations of artists seeking inspiration. Of course, as Paine's plants are crafted of polymer, rubber, aluminum, and epoxy, they can neither replicate themselves nor induce altered states and can thus be said to represent the frustrations of unrealized creative potential.

SCUMAK and *Paint Dipper,* alternately, are portents of a future in which machines will be able to mass-produce "unique" artworks, conveniently replacing artists, whose messy lives and attendant creative blocks can be inimical to productivity. The paintings and sculptures produced by these ingenious machines display a stunted creativity, however, churning out ostensibly unique objects whose similarities are nevertheless much more apparent than their differences. Even beyond the obvious dystopic implications of these works, Paine seems to comment on the limits of creativity. Though an artist may potentially conceive of thousands of different projects, somehow—is it because of an inherent drive or because the art market rewards easily identifiable styles?—they all end up looking eerily similar. AG

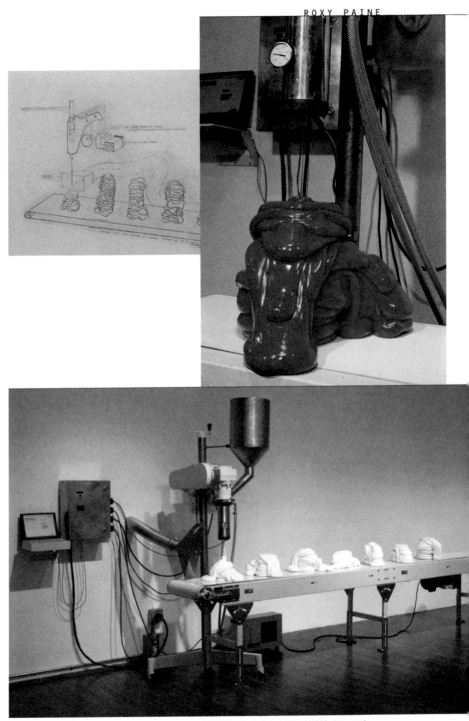

SCUMAK (Auto Sculpture Maker), 1998. Automated sculpture-making device. Private collection.

TOP LEFT: **preliminary sketch**
TOP RIGHT AND BOTTOM: **installation views**

KARIM RASHID

KARIM RASHID'S *SOFTSCAPE* (2001) IS A DREAM OF A FUTURE DOMESTIC LANDSCAPE. Like many somatic apparitions, it is soft, fuzzy, and slightly odd. In place of the hodgepodge of functional elements that make up our living spaces, Rashid offers a homogenous landscape of amorphous objects that invite us to sit or recline, to set objects on them, or merely to observe. Arranged in a checkerboard grid and surrounded by glowing walls, these elements rise seamlessly from the floor as projections of yet more fluid environments flicker across their smooth surfaces. The rational grid grows into a terrain whose peaks and valleys appeal to the human body. Rashid is completely serious about his vision of a future interior, but not in a predictive manner. While he asserts that technological changes will allow us to inhabit much more flexible environments that blend projected or electronic imagery with physical forms, he does not provide a prototype for such a space. Instead, he presents a coherent image of a kind of techno-loft that might be one outcome of the application of techniques intrinsic to the computer. He also plays with the notion that all the objects and images produced for a consumer society are flowing into similar and related shapes. It is a notion he has carried into the making of furniture, perfume bottles, and myriad other objects in his career as an industrial designer.

Here Rashid proposes that our tendency towards abstracting and rationalizing all objects of daily life into ever more functional and economical packages will lead to the creation of objects whose form is generic and friendly to the human body. This design strategy, which Rashid calls "organomics," is made possible by our ability to construct perfect forms whose complexity derives from the elisions between points computers use to map form in the digital realm. This ability to produce fluid shapes implies, in Rashid's view, a unifying style that flows from clothing to furniture to landscape without the distractions of media or manufacturing that once separated our bodies from the artificial world we created for them. Here the landscape of repose unfolding before us is covered with a thick coat of rubber, inviting us to sink into a comfortable, if slightly eerie, future. *Softscape* accommodates human presence without surrendering the surreal coherence inherent in this land of future domesticity. AB

RASHID

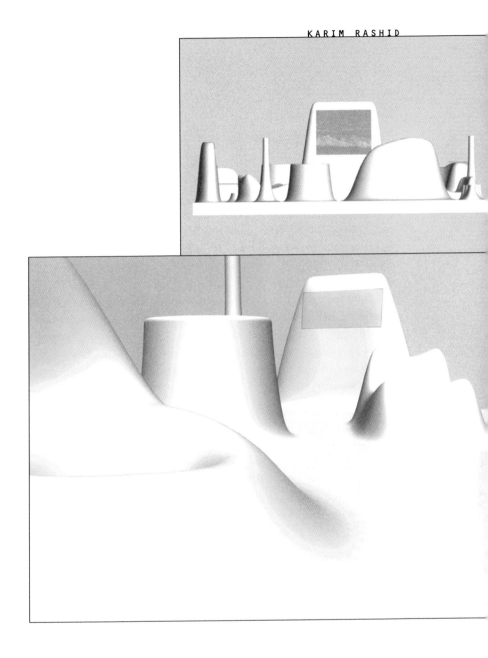

Softscape, 2001, preliminary digital renderings

MATTHEW

MATTHEW RITCHIE

MATTHEW RITCHIE'S ARTISTIC INVESTIGATIONS derive from the very simple postulate that "everything is information." He has developed a body of work based on systems that evoke scientific classification tables, making paintings, for example, that resemble charts of fictional territories. His works often function as meta-narrative structures, and his method of combining elements might be described as a kind of syntax. The formal sources for his wall drawings and floor sculptures include the works of Minimalist artists such as Carl Andre and Sol LeWitt.

In the past couple of years, Ritchie has expanded his field of research to include digital media. From 1996 to 1997 he was involved in the development of *The Hard Way*,[1] an online project whose interactive narrative composition—akin to those of computer games—offers multiple paths that trace an evolving fictional thread. The artist's description of the structure of *The Hard Way* perhaps best reveals the system on which all his work is based:

> There are forty-nine elements, divided into seven groups of seven. The seven groupings describe seven separate areas of operation in the system. Each element can appear in seven different ways depending on the context it is used in. Although the number of combinations is probably infinite, that is not the point; this is not a numerological system. The forty-nine elements are characters, with precisely defined functions in the story that is told by their interaction. This is the story of origins, of genesis and fall, as a metaphor for the construction of art.[2]

Ritchie is developing a new project, *The New Place*, which functions to some degree as a sequel to *The Hard Way*, while introducing the possibility of an investigation that is not limited to the online medium. Sculptures, paintings, computer games, and other forms yet to be determined are included in this very large cross-media plan, which is outlined in part in his contribution to *010101*. The Web project can thus be understood as a trailer, a preview of things to come. BW

NOTES
1. At http://adaweb.walkerart.org/influx/hardway.
2. Matthew Ritchie, interview with Owen Drolet, *Urban Desires 1* (March–April 1995), published online at http://desires.com/1.3.

The New Place

Astronaut	Snakes	White Lady	Golem	Actress	Bodybuilder	Baby

The New Place, 2001, digital still from Web site

ADAM

ADAM ROSS

IN MANY WAYS, THE PAINTINGS OF ADAM ROSS capture the endless sense of possibility, pleasure, and peril that exists at the heart of the entertainment-based culture in which the artist has lived since birth; if it can be imagined, it can be realized (for better or for worse), at least in the fiction of Hollywood.

The paintings in Ross's recent series The Permeability of Time within an Emerging Pattern of Change (2000) engage concepts of time travel and alternate realities that have captivated the artist (a science fiction enthusiast) since childhood. With an emphasis on the sky and what might lie beyond, these exquisitely painted works feature fields within fields that suggest parallel worlds—futuristic or faraway places pulsing with post-technological systems of energy and communication. Though undeniably seductive, these worlds are not comfortable places. The gorgeous blues skies in Untitled (The Permeability of Time within an Emerging Pattern of Change #3) and Untitled (The Permeability of Time within an Emerging Pattern of Change #4), for instance, shift into acrid oranges and violets that recall the unnatural but beautiful hues one sees in toxic flames, oil spills, or really bad air. Some of the smaller fields within the permeable membranes of the skies recall Ross's more landscape-based work and offer a grounding of sorts to the viewer. The scale and density of the shapes within them, however, exclude traces of human life.

Like the works of Yves Tanguy, Salvador Dali, and other surrealists whose illusion-istic style and tonal control added a level of realism to otherworldly imagery, Ross's paintings put forward imaginary spaces and structures that are so clear that they are descriptive or, better yet, predictive. Ross reminds us, however, that "the great thing about science fiction is that it is inevitably wrong in its predictions, yet it is this wrong-ness that makes it so entertaining and romantic."[1] As much as his paintings posit the physical shape of a future world, Ross's seemingly downloaded scenes within scenes capture psychological realities of a "hyper-instantaneous" present—an Internet-based world wherein human identity is situated less in than out of body. JB

ROSS

NOTES

1. Adam Ross, unpublished notes on the work, August 2000.

TOP: *Untitled (The Permeability of Time within an Emerging Pattern of Change #3)*, 2000

BOTTOM: *Untitled (The Permeability of Time within an Emerging Pattern of Change #4)*, 2000

CULTURE IS DOMINATED BY THE INFLUENCE OF THE CORPORATE MENTALITY AS NEVER BEFORE. ●
OUR FUTURE DEPENDS NOT ONLY ON THE SPECIFIC FORM THAT NEW TECHNOLOGIES TAKE, BUT ON WHAT KIND OF SOCIAL AND POLITICAL STRUCTURE WE CREATE AND TO WHAT ENDS THIS SOCIETY USES THESE TECHNOLOGIES. A POPULAR MOVEMENT FOR SOCIAL CHANGE MUST TAKE ADVANTAGE OF THE NEW TECHNOLOGIES TO FURTHER DEMOCRATIZE THE NATION AND TO EMPOWER THE DISENFRANCHISED. ●
IT IS NOT THE TECHNOLOGY THAT WILL REVOLUTIONIZE SOCIETY, BUT A MOVEMENT OF MILLIONS THAT MUST TRANSFORM SOCIETY. ●

Our culture is dominated by the influence of the corporate mentality as never before. Our future depends not only on the specific form that new technologies take, but on what kind of social and political structure we create and to what ends this society uses these technologies. A popular movement for social change must take advantage of the new technologies to further democratize the nation and to empower the disenfranchised. It is not the technology that will revolutionize society, but a movement of millions that must transform society. **JESSE DREW, 1995**

SCIENCE FINDS, INDUSTRY APPLIES, MAN CONFORMS
ADRIENNE GAGNON

THOUGH COINED DURING THAT HEADY PERIOD OF TECHNOLOGICAL OPTIMISM following the invention of the automobile and the birth of manned flight, the slogan[1] that serves as the title of this essay smacks of our own servility to new technologies: caught in the tumultuous wake of progress, humankind has no choice but to adapt. Whether driven by innate curiosity, utopian aspirations, or hopes of financial gain, human beings have long sought to invent new tools with which to extend their abilities. Every time we modify our biological

[1]
The phrase, "Science Finds, Industry Applies, Man Conforms" was the official slogan of the 1933 Chicago World's Fair.

and physical capabilities, however, the social structure is transformed—
often in unpredictable ways.

Most of the technologies introduced into society in recent years
have appeared to be fairly benign, aimed primarily at creating a culture
of convenience. Even such widely celebrated innovations as the Internet,
however, have had serious social consequences. While the Web is a
remarkable tool for facilitating communication with people around the
globe, it has also spawned new modes of doing business and spending
leisure time that leave us mentally and physically stressed, isolated,
and often unable to deal with the inconvenience of actual inter-
personal relationships.

In general, we remain unaware of the development of new technolo-
gies until they have arrived at our doorstep, seductively packaged as tools
for better living. It would be wonderful if, like the Amish, we were given
an open forum in which to discuss the possible implications of each new
tool before its introduction, so that we could collectively determine
whether its benefits outweighed the overwhelming tendency of such ad-
vances to erode the social fabric. But, in reality, our choices are restricted
to those of the consumer. Technologies are developed and launched with
a dizzying rapidity, and corporations throw buckets of money at ad cam-
paigns designed to convince us that these products are not just conven-
ient but essential. Sure, you could choose not to buy a cell phone . . . but
then what would you put in that Nokia-sized pouch on the chest strap of
your backpack? Resistance is not only futile; it's unfashionable.

What role should, or could, the artist play in this techno-commercial
arena? Needless to say, art is a highly personal pursuit, and responses to
technology are equally personal. To generalize a bit, however, I would say
that among those artists who choose to address technology, there are three
basic approaches. There are those who mirror the zeitgeist uncritically, by
incorporating the look and feel of the techno-culture into their work.
Others have wholeheartedly embraced technology for the increased capa-
bility it gives them to create works that engage their audience physically
and mentally on a level never before possible. Still others choose to raise
public awareness and critique the perceived excesses of technology, some-
times by employing the very technologies they aim to deconstruct.

Certainly these are all legitimate paths, and each contributes to
the necessarily complicated dialogue between technology and cultural

We have seen . . . to our amazement and distress, a marriage between science
and destruction. . . . We have always thought of science as the emancipator.
We now see it as the enslaver of mankind. **W.E.B. DUBOIS, 1945**

It is not a question of what an artist should do, but what he will do with technology. Whether technology is good or bad, threatening or friendly, beautiful or ugly is irrelevant. The qualities and shapes of technology are not the proper concern of the artist. **BILLY KLÜVER, 1967**

production. What I long to see more of, and what I believe may become essential to our existence in a world moving increasingly beyond our control, is art that recognizes the forced adaptations we make daily and strives to provide us with counter-adaptations. Artists could help us look realistically at the rapid changes and far-reaching consequences wrought by technology and provide us with the tools to assimilate them without losing our autonomy. I envision artwork that would expand the boundaries of our sensory and social capabilities, enabling us to better navigate the barrage of information we confront on a daily basis, and perhaps easing the alienation and malaise bred by the encroachment of the datascape.

I realize that this humanitarian model of artistic production is not entirely novel. Artists have long been aware that art can be a powerful tool for shaping society, and activism found its way into the art world decades ago. What I am suggesting, though, is an art form that doesn't simply rail against the perceived evils of society in an effort to effect change. This art would reflect an awareness that there may not be much we can do to alter the present course of society, and instead focus on helping us develop the resources to cope and thrive in a potentially dystopic world. And though I certainly don't presume to dictate what artists should or should not make, I do strongly believe that conscious, creative reflection on the hurdles we are facing could help us to comfortably control the integration of technology into daily life, rather than blindly following the upgrade impulse until the boundary between lived existence and binary subsistence is erased altogether.

END

KARIN

KARIN SANDER

KARIN SANDER'S 1:10 (1999–2000) IS A SERIES OF THREE-DIMENSIONAL FIGURES that are essentially reproductions of people, fully dressed, rendered one-tenth life-size in plastic. Each figure was created by a three-step process that begins with an elaborate, 360-degree computer-driven scanning apparatus that uses up to twenty cameras to produce a 3D data file describing in minute detail the appearance, posture, and clothes of the "sitter." After seeing the scan represented as a 3D "wire model" on a computer monitor, the sitter can have the technicians redo it. The final, sitter-approved data file is then sent to another company, which uses it to produce the actual 3D figure by feeding the data into a computer-driven extruder that sprays out thin layers of plastic, each representing a horizontal cross-section of the subject's body. When the figure is finished, it is sent to an airbrush artist, who colors it according to snapshots made by technicians at the time of the original scan.

Curiously, at no point in this process is Sander herself physically present. Other than accepting or (very rarely) rejecting the final product, she chooses to make no decisions concerning how the sitters will be depicted. Some subjects arrive with suitcases of clothes at the company in Kaiserslautern, Germany, that does the original scans. What they wear and how they are depicted is wholly their decision, not the artist's. Sander herself describes the work as a series of "self-portraits" made possible by methods that are the "most precise that technology can do right now." She is interested in "what's already there. I do not want to add or subtract from what the person looks like; I do not want to emphasize anything. I just want to use what's there. Either you change everything or nothing."[1]

It is hard to pinpoint what is so new and engrossing about the figures in 1:10, but there is something about these images that makes them feel different from anything handmade. They don't look like art; they look like people, little people. The effect is

SANDER

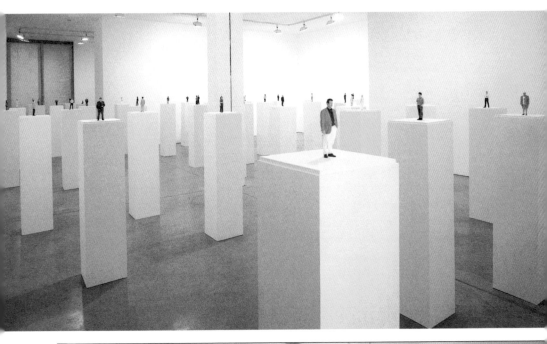

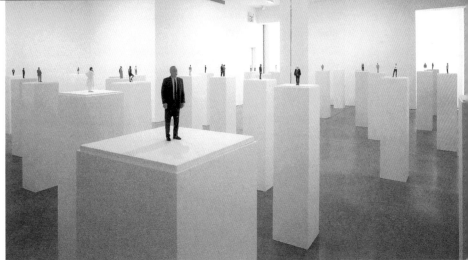

Installation photographs of the 2000 exhibition *1:10*
at D'Amelio Terras Gallery, New York.

utterly, weirdly riveting. They display all the rumpled, intense, distant, idiosyncratic qualities of people, unfiltered by an artist's subjectivity or choices. There's a sense of presence that has something to do with body language, posture, and gravity—a perfect, machine-fed depiction of how flesh and bones meet the ground. The turn of a head, the way shoulders are cocked at an angle—it's all too perfect to be the product of a single series of expressive intentions.

Calling this work "sculpture" would miss the point, but in a revealing way. It would imply a series of visual, "artistic," "hand-to-eye" decisions that are not present, decisions that the artist has specifically avoided by pushing her technical collaborators to develop new software tools and production methods. It would also divert attention from the most interesting and unexpected characteristics of these objects, namely, the strangely new resonance that is derived from their nature as veritable "copies" of fully dressed human beings.

Sculpture is made by people, but machines seemingly made these figures. It is an odd assertion, for suddenly we're back in the nineteenth century, looking at photographs for the first time and trying to decide if they are art, or science, or nature. About 1:10 as a whole, there is no doubt: this is conceptual art of a high order. Sol LeWitt said that "the idea becomes a machine that makes the art."[2] Karin Sander has pushed this dictum to a new and surprising end. JW

NOTES

1. All quotations from Karin Sander are from a conversation with the author, 31 March 2000, and from her response to an early draft of this text.

2. Sol LeWitt, "Paragraphs on Conceptual Art" (1967), in *Theories and Documents of Contemporary Art: A Sourcebook of Artists' Writings*, ed. Kristine Stiles and Peter Selz (Berkeley and Los Angeles: University of California Press, 1996), 822.

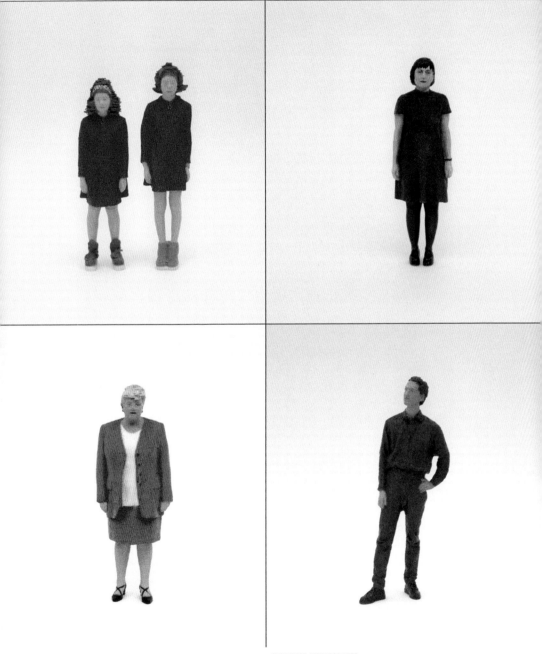

CLOCKWISE FROM TOP LEFT:
Antonia and Elisa 1:10, 2000; *Ayse Erkmen 1:10*, 1999;
Gordon Tapper 1:10, 1999; *Annemarie Becker 1:10*, 1999.

NANOTECHNOLOGICAL SYSTEMS AND URBAN PLANS . . . SPECIFICALLY INTEREST ME AS STRUCTURES SO EVER-PRESENT IN DAILY URBAN LIFE THAT THEY BOTH SUPPORT AND THREATEN US. I EXPERIENCE BOTH A GENERAL COMFORT AND FEAR THAT COMES WITH MY COMPLETE DEPENDENCE ON THESE SYSTEMS. [1]

SARAH SZE

OVER THE LAST SEVERAL YEARS SARAH SZE HAS GARNERED SIGNIFICANT ATTENTION for her stunning site-specific assemblages composed of mass-produced miscellany from our consumer society. Made from an inventive range of non-art materials like packing peanuts, toothpicks, sponges, pills, or lightbulbs—each of which we readily associate with some mundane purpose in the everyday world—these works resemble overzealous science projects, made from things on hand or from the five-and-dime, that have some-how miraculously taken on lives of their own.

Sze's sculptural macrocosms—complex constructions that pulse with life—are anal-ogous to environments undergoing rapid urban expansion wherein the rate of growth precludes adequate planning. The artist's penchant for C-clamps and hot glue adds to a sense of her process as a sort of fervent jury-rigging. Discussing her work, Sze has said, "I'm interested in an experience of the work that is disorienting, non-hierarchical and sprawling. A space that somehow has no beginning and no end, no center and no edges." [2] A second and perhaps even more apt model for considering these works is the Internet—an enormously complex association of both interlinked and distinct parts with no central core and constant, limitless growth.

Sze's project at SFMOMA builds on a recent shift in her practice away from a purely additive process to one in which a larger object serves as the focal point of the work. Each of the sculptures in her fall 2000 exhibition at Marianne Boesky Gallery in New York, for example, started with a piece of furniture, which Sze cut up and reassembled with other objects and materials. She has described this process as a pixilation of three-dimen-sional form, a notion she plans to push further at SFMOMA in a piece that involves the simulated or fictional collision of a sport utility vehicle (a 1994 red Jeep Cherokee) into the Museum's central turret and atrium. The piece will appear to have broken apart in midair, and in experiencing it, Sze predicts, one will get a "feel of morphing," as if "someone has Photoshopped a physical object." [3] JB

NOTES
1. Sarah Sze, conversation with Hans-Ulrich Obrist, in *Sarah Sze* (London: Institute of Contemporary Arts, 1998), unpaginated.
2. Ibid.
3. Sarah Sze, conversation with the author, 30 October 2000.

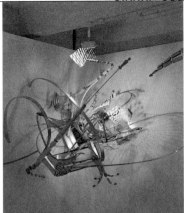

TOP: *Fractured Sculpture,* 2000, mixed media. Collection of Eileen and Peter Norton, Santa Monica, California.

MIDDLE: *Twice (White Dwarf),* 2000, mixed media. Courtesy Marianne Boesky Gallery, New York.

BOTTOM: Installation photograph of the 2000 exhibition *Sarah Sze* at Marianne Boesky Gallery, New York.

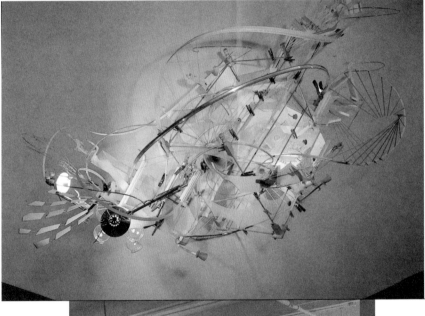

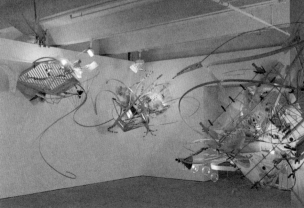

THOMSON

JON THOMSON AND ALISON CRAIGHEAD (THOMSON & CRAIGHEAD) STARTED WORKING ON-LINE IN THE EARLY STAGES OF THE WEB. The work they have been developing since is based on their acute observation of the way the Web is evolving to become an amorphous yet far-reaching medium/realm. The tradition of representation from which they borrow reflects both a conceptual intent and a formal one. In *Triggerhappy* (1996), for instance, the artists use the gaming interface to explore the notion of information compression and its effect on our comprehension of the world. In *CNN Interactive Just Became More Interactive* (1999), the notions of multitasking and diffused attention are relayed by a simple music box in a separate browser window attached to the CNN Web site. This work, like many others, addresses the way in which layers of meaning inform our perception of our daily environment. It also offers critical reflection on the transparency of the browser, that window onto the network, whose functionality conditions our relationship to data streams and, thus, meaning.

With *e-poltergeist* (2001), the artists take this notion one step further. Like the CNN piece, this work not only addresses the Internet as a cultural construct (employing buzzwords such as *interactive* and *e*-whatever) but also considers the visible and the invisible, that which is being overtly solicited and that which is happening without our knowledge. In this instance, the delivery of code creates an invisible canvas, which then distributes random sound bites from a series of preselected URLs. This omnipresent stream of sound, collected by an invisible browser, also suggests the blurring boundary between the desktop and the remote server. BW

CRAIGHEAD

09.01.01. e-poltergeist.
Banner ad cycle.

1

one add for furniture finder.

CLOSE

2 elements

when flash element is closed reopen 4 banners as blank & window No.

CLOSE

beginning of endless loop

close

from No window to '-blan

1 2 3 4

CLOSE

5 6 7 8

9 10 11 12

12 14 15 16 17 18

no. of window will vary depending on how often banners are closed.

etc....

some windows rearrange
some proliferate.
The more end users close them the more will open ideally.
until either: BROWSER CRASHES.
USER QUITS BROWSER

e-poltergeist, 2001, preliminary sketch

SHIRLEY

SHIRLEY TSE

PLASTIC IS POLYMORPHOUS; it can be transformed to suit almost any need. It can be strong and durable, lightweight and flexible, transparent, opaque, or translucent, and it can be made in virtually any color. Shirley Tse revels in plastic's mutability, employing everything from bubble wrap to polystyrene blocks to create her work. She has crafted towering sculptures of garbage bags, supported by nothing more than the air within, and tiny reliefs composed of colored drinking straws woven into the blister cards used to pack Christmas lights.

But Tse's fascination with plastic extends far beyond its formal properties. She views plastic, prized progeny of the industrial era, as the tacit enabler of the electronic age we now inhabit: "The digital world doesn't exist in a vacuum, but amid plastic computer parts."[1] Custom-molded foam, precisely shaped to cushion electronic goods for shipping, especially enchants her. The intricate geographies of such packing materials seem an apt metaphor for the recent cultural trend toward customization of just about everything.

For all their careful crafting, however, these foam molds represent nothing more than the space between and are ultimately consigned to a landfill. In recent works such as *Polymathicstyrene 1* (1999–2000), Tse has salvaged a number of these foam supports and carved into them using a hand-held power tool. Her excavations of the polystyrene range from rigid geometric patterns reminiscent of circuit boards to lyrical curves and swells. *Polyworks* (2000–2001) expands upon this concept, successfully introducing the human gesture into mass-produced forms, while employing a tool that is itself limited by the predetermined shapes of its bits. Tse sees this encounter between the human and the machine-made not as an oppositional relationship, but as an extension of the essence of the original plastic, a further customization of the already highly customized. AG

TSE

NOTES
1. Shirley Tse, "Technology, Plastic, and Art" (lecture delivered in 1998).

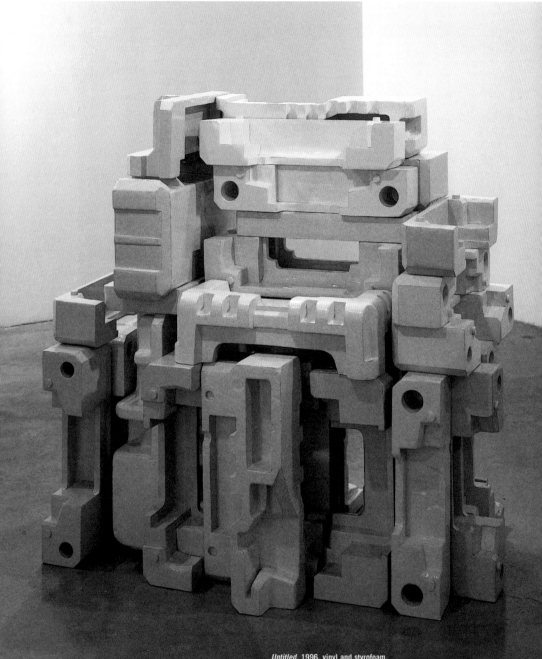

Untitled, 1996, vinyl and styrofoam.
Courtesy Shoshana Wayne Gallery,
Santa Monica, California.

YUAN

THE ANXIETY SURROUNDING THE QUESTION OF WHAT DEFINES OUR EXISTENCE IN AN AGE OF DIGITAL PROJECTS is the subject of Yuan Goang-ming's video installation *Scream, Therefore I Am* (1997). Just as Edvard Munch captured the anxiety engendered by the modern city at the beginning of the twentieth century, so Yuan has now given us a very similar picture of a man brought to the same state by what is left of the urban environment at the cusp of the twenty-first century. For Yuan, the confusion about identity is sharpened by his position as a Taiwanese artist trained in Germany trying to define the exact nature of his nationality and ethnicity.

It is not just who one is that is in question here, however, but the whole matter of perception and reality. In many of Yuan's works, projectors and recordings are used to give hints of an image or thing that might be there but cannot be touched or directly seen. In *Scream, Therefore I Am,* the artist uses phosphorous material to capture the projection of a face. Phosphor has the ability to retain light for a short amount of time so that the image remains even after the projector is turned off. Then the face screams, and the vibrations produced by the sound cause the image to dissolve, leaving only the equipment that made it appear. The reality of the piece is thus technology itself, which both allows us to present ourselves and contains our presence. The rest is only the product of our own imagination, fear, and hope—and the flitting apprehension of an image. AB

GOANG-MING

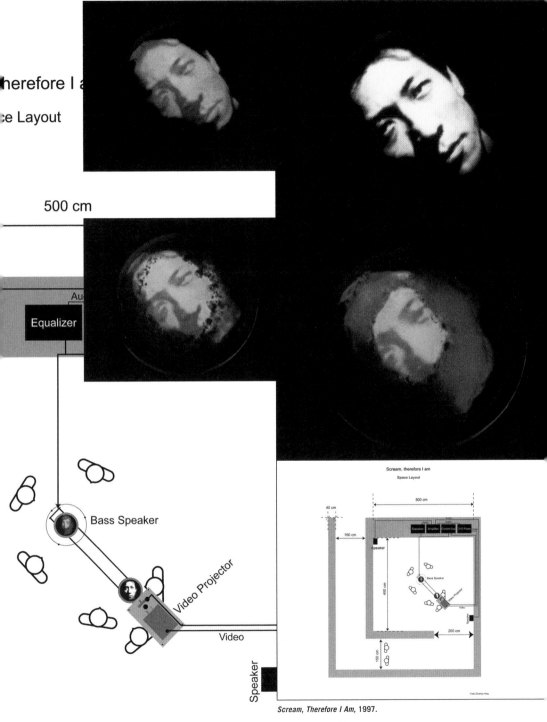

Scream, Therefore I Am, 1997.

TOP RIGHT: **video still**
TOP LEFT AND MIDDLE: **projected images captured in phosphor powder**
BOTTOM: **installation plan**

No more subject, focal point, center, or periphery: but pure flexion or circular inflection. No more violence or surveillance: only "information," secret virulence, chain reaction, slow implosion, and simulacra of spaces where the real-effect again comes into play. **JEAN BAUDRILLARD, 1983**

No

MORE SUBJECT, FOCAL POINT, CENTER, OR PERIPHERY:

but pure flexion or circular inflection. No more violence or surveillance: only "information," secret virulence, chain reaction, slow implosion, and simulacra of spaces where the real-effect again comes into play.

WHAT

[BAUDRILLARD'S] TEXTS EXCLUDE IS ANY SENSE OF BREAKDOWN, OF FAULTY CIRCUITS, OF SYSTEMIC MALFUNCTION;

or of a body that cannot be fully colonized or pacified, of disease, and of the colossal dilapidation of everything that claims infallibility or sleekness.

What [Baudrillard's] texts exclude is any sense of breakdown, of faulty circuits, of systemic malfunction; or of a body that cannot be fully colonized or pacified, of disease, and of the colossal dilapidation of everything that claims infallibility or sleekness. **JONATHAN CRARY, 1984**

ANCHORS AWEIGH!

ERIK DAVIS

IN 1985, AT AN ART SCHOOL OPEN HOUSE, I bumped into the scruffy, taciturn sculptor who served as the TA for my undergraduate drawing class. He asked me if I had ever heard of Jean Baudrillard. Then he slipped me the slim blue-black Semiotext(e) volume of *Simulations,* briefly glancing around as if he were handing over a vial of crack or a collection of truly scandalous pornography.

Which in a way he was. Unlike most of the theory they were shoving down our gullets, Baudrillard seduced, his profane illuminations injecting some of *Neuromancer's* cynical crackle into the dawning world of cybercrit. Though his inflationary videodrome rants became the model for what the media

1.

PETER
LUNENFELD,
Snap to Grid
(CAMBRIDGE: MIT
PRESS, 2000), 33–36.

arts critic Peter Lunenfeld later attacked as "vapor theory," [1] Baudrillard was not just a theorist; his writings helped induce the hyperreality he described. His work announced that if thought was going to keep up with our galloping media void, it would have to go SF: speculative, techno-fetishist, even, in an utterly exhausted way, visionary.

Baudrillard's most visionary image was implosion, his term for the structural, semiotic, and social collapse that undermines, among other things, traditional positions of social resistance and critique. Capitalism, following its explosive course over the last few centuries, reaches a turning point: having achieved hegemony over productive and symbolic forces, the system collapses in on itself, taking the real with it. Representation gives way to the simulacrum; meaning, to the code.

In astrophysics, implosion describes what happens when a massive star collapses into the dimensionless singularity that forms the heart of a black hole. In our world, implosion is most obviously catalyzed by the media, which dissolves the boundaries between sectors of the real, intensifying the feedback loops wherein signs and images, commodities and data, circulate through institutions and individuals. The speed and intensity of these flows erode traditional structures of knowledge, communication, and culture—indeed, they erode "structure" in general, giving way to a world of process and mutation. Expanding on Marshall McLuhan's insights, Baudrillard argued that the media's primary object of dissolution was the boundary between media and everything else: "There are no more media in the literal sense of the word—that is, of a mediating power between one reality and another, between one state of the real and another." [2]

2.

JEAN
BAUDRILLARD,
Simulacra and Simulation
(ANN ARBOR:
UNIVERSITY OF
MICHIGAN
PRESS, 1994), 81

But this is just the beginning. The ouroboros of information flows finally feasts not only on the social but on time and space as well. This is where implosion phases into the apocalyptic—voided of redemption, but no less absolute. Baudrillard's haunting image of man as nothing more than a node, a passive switch channeling networks of influence, is but a morose inversion of the subject at the end of history, with the final revelation being a thousand screens and satellites. This media eschatology is not peculiar to Baudrillard. McLuhan already spoke of the immersive and all-consuming character of the electronic environment, which shattered linear rationality and opened up an endlessly echoing now. "Time and Space died yesterday," Marinetti boasted

May not man himself become a sort of parasite upon the machines? An affectionate machine-tickling aphid? **SAMUEL BUTLER, 1872**

decades before that, recognizing that technology unleashes an almost alchemical transmutation of the real. "We already live in the absolute, because we have created eternal, omnipresent speed." [3]

With cyberpunk sneers and the ridiculous void of Y2K behind us, we are justified in finding the apocalyptic strain of postmodern critique rather old news. Here is the future, all around us: genetic engineering, chaotic weather, global fads, cyborg implants, robots, personality-modification pills, information everywhere. It's not a picnic, but it's hardly dull. The dominance of the simulacrum has not stopped the creativity of the cosmos, and while "we" may not make the future, the future is certainly being made. It begs us to join in.

It's not that implosion was hogwash, the depleted fantasy of a dystopian philosopher without a hacker's bone in his body. Instead, we may have stumbled on the most hushed of eschatological secrets: that the apocalypse *already happened*. In other words, the implosion has occurred, or at least already begun, and yet life still demands to be lived. Only now we are posthumans living it.

After all, implosion is not just a structural process—it is subjective, phenomenological. Where else do time and space break down but in the body of a perceiver? If implosion has any validity at all—and surely it does, if only as an inflated allegory of speed and technocapitalist convergence—then we will feel it in our nervous systems, if not our bones. "I was an infinitely hot and dense dot," Mark Leyner tells us. [4] We get to find out what this feels like. Intimations of the infinitesimal, as when you can no longer tell the difference between Times Square and Shibuya, or when all airports fuse into one, or when your wireless data device, rather than unleashing your inner nomad, reduces your physical movement through space to a shadowy projection of an incorporeal matrix. Today's music collapses into dimensionless data files; the new dollar bills are tattooed with molecular print; and micro-targeted marketing mechanisms reflect you back to yourself, everywhere you turn. Implosion, the feedback of free-fall fusion, is the insistent overtone of contemporary experience.

So are we condemned to the frozen pessimism of too-late critique? I don't believe so. Far from dampening the powers of emergence, the supposed reign of the simulacrum has simply introduced new dimensions into the fabric of space-time. The black hole is not chaos; it has structure

3.
FILIPPO TOMMASO MARINETTI, "The Founding and Manifesto of Futurism [1909]," in *Futurist Manifestos*, ed. Umbro Apollonio, trans. Robert Brain et al. (NEW YORK: VIKING, 1973), 22.

4.
MARK LEYNER, *My Cousin, My Gastroenterologist* (NEW YORK: HARMONY, 1990), 5.

The change from atoms to bits is irrevocable and unstoppable.
NICHOLAS NEGROPONTE, 1995

and pattern. Today is also a time of intertwining, where elements of the real are linked and drawn together, and patterns of resemblance echo across scale and milieu. Implosion shifts the center, evacuates substance, but does not destroy the productive possibilities of organization and design. Implosion is not just collapse; alongside it, or perhaps identified with it, there is recombination. So everywhere you turn you find networks of linkages, proliferating between domains previously estranged: philosophy, photons, market indexes, prana, microfibers, neurotransmitters, quanta, beats. These linkages suggest invisible exchanges, points of resonance, shared unfoldings that draw the mind into the heart of the matter, bringing it all back home.

This sense of secret sharing helps explain the growing desire to transcode the real, as when one signal source (Web traffic, a trumpet, the rate of rain forest loss) is translated into data that mutates into another form (3D models, machine rhythms, articulations of a robot arm). What exactly happens in these events? Are the patterns and affects suggested by such processes part of the world, or simply artifacts of the criteria of translation? This ancient problem—is the form in the world or the eye?—is suspended in the new operations of the transcoding mix, which makes the phenomena it describes. The nodes around us—the nodes that we are—are not passive switches, but grow in strength and insight through their range of materials, the nature and novelty of their connections and mutual exchanges. Cosmic eros is not exhausted, and implosion may only be a media-induced hallucination of an emerging nest of integration.

END

a
bug.

EVERY SYSTEM HAS A BUG. THE MORE COMPLEX THE SYSTEM, THE MORE BUGS. TRANSACTIONS CIRCLING THE EARTH, PASSING THROUGH THE COMPUTER SYSTEMS OF TENS OR HUNDREDS OF CORPORATE ENTITIES, THOUSANDS OF NETWORK SWITCHES, MILLIONS OF LINES OF CODE, TRILLIONS OF INTEGRATED CIRCUIT LOGIC GATES. SOMEWHERE THERE IS A FAULT. SOMETIME THE FAULT WILL BE ACTIVATED. NOW OR NEXT YEAR, SOONER OR LATER, BY DESIGN, BY HACK, OR BY ONSLAUGHT OF COMPLEXITY. IT DOESN'T MATTER. ONE DAY SOMEONE WILL INSTALL TEN LINES OF ASSEMBLER CODE, AND IT WILL ALL COME DOWN.

A bug. Every system has a bug. The more complex the system, the more bugs. Transactions circling the earth, passing through the computer systems of tens or hundreds of corporate entities, thousands of network switches, millions of lines of code, trillions of integrated circuit logic gates. Somewhere there is a fault. Sometime the fault will be activated. Now or next year, sooner or later, by design, by hack, or by onslaught of complexity. It doesn't matter. One day someone will install ten lines of assembler code, and it will all come down. **ELLEN ULLMAN, 1997**

CATALOGUE OF THE EXHIBITION

The following list represents the most complete information available as of January 1, 2001. In a few cases, it was not possible to provide full documentation for an artwork, as the piece was in progress at the time of publication. Such instances are noted below. Thanks go to Kathleen Forde, Adrienne Gagnon, Jason Goldman, and Randy Nordschow for their efforts in compiling this catalogue of the exhibition.

ERIK ADIGARD/M.A.D.
French, b. 1953, lives in San Francisco

Timelocator, 2001
Online commission
Media: DHTML, Javascript
Browser requirements: Netscape 4.0+ and
 Internet Explorer 4.0+
Courtesy of the artist

Contributor/programmer: Dave Thau
Contributor: Patricia McShane

KEVIN APPEL
American, b. 1967, lives in Los Angeles

House Revision 1, 2000–2001
Acrylic and oil on canvas over panel
80 x 94 in. (203.2 x 238.8 cm)
Courtesy of the artist and Angles Gallery,
 Santa Monica, California

House Revision 2, 2000–2001
Acrylic and oil on canvas over panel
80 x 94 in. (203.2 x 238.8 cm)
Courtesy of the artist and Angles Gallery,
 Santa Monica, California

House Revision 3, 2000–2001
Acrylic and oil on canvas over panel
80 x 94 in. (203.2 x 238.8 cm)
Courtesy of the artist and Angles Gallery,
 Santa Monica, California

Note: The images included in the entry for this artist do not correspond to the artworks exhibited in *010101,* as photographic documentation of the latter was not available.

ASYMPTOTE ARCHITECTURE
Lise Anne Couture and Hani Rashid
Studio founded 1988, New York

I-Scapes 1.0, 1999
Mini DV player, digital videotape, Plexiglas, wood
16 5/8 x 12 x 12 in. (42.2 x 30.5 x 30.5 cm)
Duration continuous
Collection of the San Francisco Museum of
 Modern Art, Accessions Committee Fund

HEIKE BARANOWSKY
German, b. 1966, lives in Berlin and London

AUTO SCOPE, 1996–97
Four-channel video projection
Dimensions variable
Duration continuous (60:00 loop)
Media: BetaSP (authored to DVD)
Equipment: four LCD projectors, one DVD player
Courtesy of Galerie Barbara Weiss, Berlin

ANNETTE BEGEROW
German, b. 1964, lives in Berlin

Constant Memory, Entering the surface (projected), 1999
Computer-generated projection
Dimensions variable; projected image measures
 approx. 157 1/2 x 118 1/8 in. (400 x 300 cm)
Duration continuous
Media: real-time computer-generated data projection
Equipment: Apple Powerbook G3, data projector,
 prepared surface
Collection of the Institut für Auslandsbeziehungen,
 Stuttgart/Berlin

Software shell: Tom Demeyer, Stichting STEIM,
 Amsterdam
Software development: Sukandar Kartadinata, Berlin

JEREMY BLAKE
American, b. 1971, lives in New York

Guccinam, 2000
Digital animation with sound
Duration continuous (7:30 loop)
Media: DVD
Equipment: 50-inch flat plasma screen, DVD player
Edition: 5, 1 AP
Collection of the San Francisco Museum of
 Modern Art

Liquid Villa, 2000
Digital animation with sound
Duration continuous (7:30 loop)
Media: DVD
Equipment: 50-inch flat plasma screen, DVD player
Edition: 5, 1 AP
Collection of Chris Vroom, courtesy of Feigen
 Contemporary, New York

REBECA BOLLINGER
American, b. 1960, lives in San Francisco

clouds and clouds, 1999
Colored pencil on vellum
38 x 25 in. (96.5 x 63.5 cm)
Courtesy of Rena Bransten Gallery, San Francisco

people communicating, 1999
Colored pencil on vellum
38 x 25 in. (96.5 x 63.5 cm)
Collection of Doug Hall and Diane Anderson Hall

people on grass, 1999
Colored pencil on vellum
38 x 25 in. (96.5 x 63.5 cm)
Courtesy of Rena Bransten Gallery, San Francisco

drive, 2000
Colored pencil on vellum
38 x 25 in. (96.5 x 63.5 cm)
Courtesy of Rena Bransten Gallery, San Francisco

Ed Glaze, 2000
Colored pencil on vellum
14 x 17 in. (35.6 x 43.2 cm)
Courtesy of Rena Bransten Gallery, San Francisco

Important Documents, 2000
Colored pencil on vellum
38 x 25 in. (96.5 x 63.5 cm)
Courtesy of Rena Bransten Gallery, San Francisco

My Van, 2000
Colored pencil on vellum
14 x 17 in. (35.6 x 43.2 cm)
Courtesy of Rena Bransten Gallery, San Francisco

"need," 2000
Colored pencil on vellum
12 x 9 in. (30.5 x 22.9 cm)
Courtesy of Rena Bransten Gallery, San Francisco

Photo Albums, 2000
Colored pencil on vellum
38 x 25 in. (96.5 x 63.5 cm)
Courtesy of Rena Bransten Gallery, San Francisco

Some population charts and graphs, 2000
Colored pencil on vellum
14 x 17 in. (35.6 x 43.2 cm)
Courtesy of Rena Bransten Gallery, San Francisco

tv rv, 2000
Colored pencil on vellum
Two sheets, each 12 x 9 in. (30.5 x 22.9 cm)
Courtesy of Rena Bransten Gallery, San Francisco

Views, 2000
Colored pencil on vellum
14 x 17 in. (35.6 x 43.2 cm)
Courtesy of Rena Bransten Gallery, San Francisco

JANET CARDIFF
Canadian, b. 1957, lives in Alberta, Canada

The Telephone Call, 2001
Audio and video walk through the San Francisco
 Museum of Modern Art
Duration: 17:00
Media: digital videotape
Equipment: mini DV camera, headphones
Courtesy of the artist

Note: The image included in the entry for this
artist does not correspond to the artwork exhibited in
010101, as photographic documentation of the latter
was not available.

CHRIS CHAFE / GREG NIEMEYER
Chafe: American, b. 1952, lives in Palo Alto, California
Niemeyer: Swiss, b. 1967, lives in Palo Alto, California

Ping, 2001
Networked sound installation
Dimensions variable
Media: SoundWIRE, soundping software,
 Linux Operating System
Equipment: eight loudspeakers, control wheel,
 two computers, LCD monitor
Courtesy of the artists

CHAR DAVIES
Canadian, b. 1954, lives in Montreal

Osmose, 1995
Immersive virtual-reality installation
Dimensions variable
Media: immersive virtual environment
Equipment: computers, sound synthesizers and
 processors, stereoscopic head-mounted display with
 3D localized sound, interface vest, motion-capture
 devices, video projector, silhouette screen
Collection of the artist

Ephémère, 1998
Immersive virtual-reality installation
Dimensions variable
Media: immersive virtual environment
Equipment: computers, sound synthesizers and
 processors, stereoscopic head-mounted display with
 3D localized sound, interface vest, motion-capture
 devices, video projector, silhouette screen
Collection of the artist

Additional technical assistance for both artworks:
John Harrison (custom VR software), Georges Mauro
(computer graphics), Dorota Blaszczak (sonic
architecture/programming), Rick Bidlack (sound
composition/programming)

DÉCOSTERD & RAHM, ASSOCIÉS
Jean-Gilles Décosterd and Philippe Rahm
Studio founded 1993, Lausanne, Switzerland

Melatonin Room, 2001
Physiological spaces (sleep/awakening)
Halogen and ultraviolet lamps, acrylic partitions,
 gymnastic mats, steel bar, ABS (acrylonitrile-
 butadiene-styrene) plastic ball
318 x 318 in. (807.7 x 807.7 cm)
Collection of Décosterd and Rahm, associés

DROOG DESIGN
Gijs Bakker, Ed van Hinte, Matijs Korpershoek,
 Renny Ramakers, Lauran Schijvens, Ries Straver,
 and Thomas Widdershoven
Studio founded 1993, Amsterdam

System Almighty, 2001
Mixed-media installation [media not available]
Dimensions variable
Courtesy of the artists

BRIAN ENO
British, b. 1948, lives in London

[title not available], 2001
Generative sound installation with mixed media
Dimensions variable
Duration continuous
Media: [not available]
Equipment: [not available]
Courtesy of the artist

ENTROPY8ZUPER!
Auriea Harvey and Michaël Samyn
Studio founded 1999, Ghent, Belgium

Eden.Garden 1.0, 2001
Online commission
Media: HTML, Javascript, Perl, Pulse3D, Flash
Browser requirements: Netscape 4.0+ or Internet
 Explorer 4.0+ (PC only)
Plug-in requirements: Pulse3D 4+ and Flash 5
Courtesy of the designers

CHRIS FINLEY
American, b. 1971, lives in Pengrove, California

Goo Goo Pow Wow, 2000–2001
Sign enamel on canvas over wood
90 x 180 in. (228.6 x 457.2 cm)
Courtesy of ACME, Los Angeles

RODNEY GRAHAM
Canadian, b. 1949, lives in Vancouver, Canada

Edge of a Wood, 1999
Two-channel video projection with sound
Dimensions variable
Duration continuous (8:00 loop)
Media: DVD
Equipment: two DVD players, two projectors, six
 speakers, AV receiver, custom synchronizer
Courtesy of Donald Young Gallery, Chicago

ANDREAS GURSKY
German, b. 1955, lives in Düsseldorf

99 Cent, 1999
C-print
81 $^{1}/_{2}$ x 132 $^{5}/_{8}$ in. (207 x 336.9 cm)
Courtesy of the artist and Matthew Marks Gallery,
 New York

Taipei, 1999
C-print
46 $^{1}/_{8}$ x 58 $^{3}/_{4}$ in. (117.2 x 149.2 cm)
Private collection

JOCHEM HENDRICKS
German, b. 1957, lives in Frankfurt

Gemälde (Painting), 1992
Ink on paper
24 x 16 $^{15}/_{16}$ in. (61 x 43 cm)
Courtesy of the artist

Hand (linkes Auge) (Hand [left eye]), 1992
Ink on paper
24 x 16 $^{15}/_{16}$ in. (61 x 43 cm)
Courtesy of the artist

Hand (rechtes Auge) (Hand [right eye]), 1992
Ink on paper
24 x 16 $^{15}/_{16}$ in. (61 x 43 cm)
Courtesy of the artist

Lesen (Reading), 1992
Ink on paper
24 x 16 $^{15}/_{16}$ in. (61 x 43 cm)
Courtesy of the artist

Licht (Light), 1992
Ink on paper
24 x 16 $^{15}/_{16}$ in. (61 x 43 cm)
Courtesy of the artist

Nachbild (Afterimage), 1992
Ink on paper
24 x 16 $^{15}/_{16}$ in. (61 x 43 cm)
Courtesy of the artist

Schreibtisch (Desk), 1992
Ink on paper
24 x 16 $^{15}/_{16}$ in. (61 x 43 cm)
Courtesy of the artist

Blinzeln (Blinking), 1993
Ink on paper
24 x 16 $^{15}/_{16}$ in. (61 x 43 cm)
Courtesy of the artist

Fernsehen (Watching TV), 1993
Ink on paper
24 x 16 $^{15}/_{16}$ in. (61 x 43 cm)
Courtesy of the artist

Nichts (Nothing), 1993
Ink on paper
24 x 16 $^{15}/_{16}$ in. (61 x 43 cm)
Courtesy of the artist

Schreiben (Writing), 1993
Ink on paper
24 x 16 $^{15}/_{16}$ in. (61 x 43 cm)
Courtesy of the artist

Zeichnen (Drawing), 1993
Ink on paper
24 x 16 $^{15}/_{16}$ in. (61 x 43 cm)
Courtesy of the artist

Zeit (Time), 1993
Ink on paper
24 x 16 $^{15}/_{16}$ in. (61 x 43 cm)
Courtesy of the artist

Eye, 2000
Offset lithography
48 pages, each 13 $^{1}/_{2}$ x 11 $^{3}/_{8}$ in. (34.3 x 28.9 cm)
Edition: 5,000
Courtesy of the artist and the San Francisco
 Museum of Modern Art

HU JIE MING
Chinese, b. 1957, lives in Shanghai

The Fiction between 1999 & 2000, 2000
Mixed-media installation with sound
Transparent film, aluminum frame, nine CD players,
 nine CDs, nine speakers
192 x 288 x 252 in. (487.7 x 731.5 x 640.1 cm)
Courtesy of the artist

Note: The images included in the entry for this
artist do not correspond to the artwork exhibited in
010101, as photographic documentation of the latter
was not available.

CRAIG KALPAKJIAN
American, b. 1964, lives in New York

Corridor, 1995
Computer-generated animation
Duration continuous
Media: laserdisc
Equipment: 27-inch monitor, laserdisc player
Collection of the San Francisco Museum of
 Modern Art, Accessions Committee Fund

LEE BUL
South Korean, b. 1964, lives in Seoul

Supernova, 2000
Hand-cut polyurethane panels on aluminum
 armature with polyurethane coating
114 $\frac{3}{16}$ x 114 $\frac{3}{16}$ x 114 $\frac{3}{16}$ in. (290 x 290 x 290 cm)
Courtesy of the artist and Kukje Gallery, Seoul

EUAN MACDONALD
Canadian, b. 1965, lives in Los Angeles

Two Planes, 1998
Single-channel video with sound
Dimensions variable
Duration continuous (3:30 loop)
Media: BetaSP (transferred to $\frac{3}{4}$-inch videotape)
Equipment: $\frac{3}{4}$-inch U-matic video player,
 27-inch monitor
Edition: 10, 1 AP
Courtesy of Jack Hanley Gallery, San Francisco

JOHN MAEDA
American, b. 1966, lives in Boston

Tap Type Write, 1998
Interactive typographic experiment
Media: custom software
Equipment: Apple Macintosh G3, keyboard,
 19-inch monitor
Collection of the San Francisco Museum of
 Modern Art, Gift of John and Kris Maeda

TATSUO MIYAJIMA
Japanese, b. 1957, lives in Ibaraki, Japan

Floating Time, 2000
Computer-generated projection
Dimensions variable
Duration continuous
Media: custom software
Equipment: personal computer, digital projector
Courtesy of the artist and Luhring Augustine,
 New York

MARK NAPIER
American, b. 1961, lives in New York

Feed, 2001
Online commission
Media: Javascript, CGI script
Browser requirements: Netscape 4.0+ or
 Internet Explorer 4.0+
Courtesy of the artist

ROXY PAINE
American, b. 1966, lives in Brooklyn

SCUMAK no. 2, 2001
Automated sculpture-making device
Apple PowerBook running custom software with
 interface, extruder, conveyor with Teflon belt,
 motor, stainless steel, polyethylene, pigment
96 x 240 x 48 in. (243.8 x 609.6 x 121.9 cm)
Courtesy of the artist and James Cohan Gallery,
 New York

Note: The images included in the entry for this
artist do not correspond to the artwork exhibited in
010101, as photographic documentation of the latter
was not available.

KARIM RASHID
Egyptian, b. 1960, lives in New York

Softscape, 2001
[medium and dimensions not available]
Courtesy of the artist

MATTHEW RITCHIE
British, b. 1964, lives in New York

The New Place, 2001
Online commission
Media: Flash
Browser requirements: Netscape 4.0+ or
 Internet Explorer 4.0+
Plug-in requirements: Flash 5
Courtesy of the artist and Andrea Rosen Gallery,
 New York

Additional production design: Brian Clyne and
 Connie Purtill

ADAM ROSS
American, b. 1962, lives in Altadena, California

*Untitled (The Permeability of Time within an Emerging
 Pattern of Change #3)*, 2000
Oil, alkyd, and acrylic on canvas
48 x 72 in. (121.9 x 182.9 cm)
Courtesy of Shoshana Wayne Gallery, Santa
 Monica, California

*Untitled (The Permeability of Time within an Emerging
 Pattern of Change #4)*, 2000
Oil, alkyd, and acrylic on canvas
48 x 72 in. (121.9 x 182.9 cm)
Courtesy of Shoshana Wayne Gallery, Santa
 Monica, California

*Upon the Notion of a Minor Disturbance
 (after Lissitzky #5)*, 2000
Oil, alkyd, and acrylic on canvas
48 x 96 in. (121.9 x 243.8 cm)
Courtesy of Shoshana Wayne Gallery,
 Santa Monica, California

KARIN SANDER
German, b. 1957, lives in Stuttgart, Germany

1:10, 1999–2000
Three-dimensional body scan of the original subject
 (fused deposition modeling), rapid prototyping, ABS
 (acrylonitrile-butadiene-styrene) plastic, airbrush
Each figure exactly 1:10 scale

Annemarie Becker 1:10, 1999
Dietmar Glatz 1:10, 1999
Herr Schmidt 1:10, 1999
Midori Nishizawa 1:10, 1999
Paul Müller 1:10, 1999
Peter Friese 1:10, 1999
Reinhold Gondrom 1:10, 1999
Volker Fiebiger 1:10, 1999
Waltraud Sonal 1:10, 1999
Anna Froehlich 1:10, 2000
Josef W. Froehlich 1:10, 2000
David Ross 1:10, 2000
Michael Stephan 1:10, 2000
John Weber 1:10, 2000
Courtesy of the artist and D'Amelio Terras Gallery,
 New York

Adrian Koerfer 1:10, 2000
Antonia and Elisa 1:10, 2000
Collection of Mondstudio, Frankfurt

Karin Sander 1:10, 1999
Kasper and Johann König 1:10, 1999
Martin Lauffer 1:10, 2000
Private collection, Germany

SARAH SZE
American, b. 1969, lives in New York

[title not available], 2001
Site-specific mixed-media installation
[media and dimensions not available]
Courtesy of Marianne Boesky Gallery, New York

Note: The images included in the entry for this artist
do not correspond to the artwork exhibited in
010101, as photographic documentation of the latter
was not available.

THOMSON & CRAIGHEAD
Jon Thomson and Alison Craighead
Studio founded 1994, London

e-poltergeist, 2001
Online commission
Media: HTML, Javascript, Flash
Browser requirements: Netscape 4.0+ or
 Internet Explorer 4.0+
Plug-in requirements: Flash 5 and an audio plug-in
 configured to play MIDI files
Courtesy of the artists and Mobile Home
 Gallery, London

SHIRLEY TSE
Chinese, b. 1968, lives in Pasadena, California

Polyworks, 2000–2001
Polystyrene and vinyl
36 x 78 x 84 in. (91.4 x 198.1 x 213.4 cm)
Courtesy of Shoshana Wayne Gallery, Santa
 Monica, California

Note: The image included in the entry for this artist
does not correspond to the artwork exhibited in
010101, as photographic documentation of the latter
was not available.

YUAN GOANG-MING
Taiwanese, b. 1965, lives in Taipei

Scream, Therefore I Am, 1997
Video and sound installation
118 x 209 x 209 in. (300 x 530 x 530 cm)
Duration continuous
Media: DVD
Equipment: DVD player, video projector, auto control
 device, bass speaker, phosphor powder
Collection of the Taipei Fine Arts Museum

ADDITIONAL WORKS DRAWN FROM THE PERMANENT COLLECTION OF SFMOMA
(Not Illustrated in Catalogue)

DILLER + SCOFIDIO
Elizabeth Diller and Ricardo Scofidio
Studio founded 1979, New York

Non-Place, 1997
McDonald's hamburger wrapper, $^{1}/_{2}$-inch VHS player,
 video projector, videotape
Dimensions variable
Collection of the San Francisco Museum of Modern
 Art, Accessions Committee Fund

KOLATAN/MAC DONALD STUDIO
Sulan Kolatan and William J. Mac Donald
Studio founded 1986, New York

Blast Vehicles, 1996
Fiberglass
Collection of the San Francisco Museum of Modern
 Art, Accessions Committee Fund

Dimensions of individual pieces:

Vhcl AB_a
1 3/8 x 3 x 2 3/4 in. (3.5 x 7.6 x 7 cm)

Vhcl BA_b
1 1/2 x 8 5/8 x 2 5/16 in. (3.8 x 21.9 x 5.9 cm)

Vhcl BB_a
1 5/8 x 3 x 3/4 in. (4.1 x 7.6 x 1.9 cm)

Vhcl CA_a
1 7/8 x 3 x 2 in. (4.8 x 7.6 x 5.1 cm)

Vhcl CB_b
2 1/2 x 8 1/2 x 4 1/4 in. (6.4 x 21.6 x 10.8 cm)

LISA KROHN
American, b. 1963, lives in Los Angeles

Cyberdesk, 1993
Cast elastomeric silicone resin and metal
30 x 10 x 11 in. (76.2 x 25.4 x 27.9 cm)
Collection of the San Francisco Museum of Modern
 Art, Gift of the artist

MICHAEL McCOY
American, b. 1944, lives in Chicago

Haptic Software Controller, 1995
Silicon
8 1/2 x 5 x 1 in. (21.6 x 12.7 x 2.5 cm)
Collection of the San Francisco Museum of Modern
 Art, Gift of Fahnstrom/McCoy

SAMSUNG ELECTRONICS DESIGN INSTITUTE
Founded 1971, Seoul

Tamio Fukuda
DVD Handy Navigation System Prototype, 1996
Plastic
3 3/4 x 5 3/16 x 3 1/8 in. (9.5 x 13.1 x 7.9 cm)
Collection of the San Francisco Museum of Modern
 Art, Gift of Samsung Electronics Design Institute

Tamio Fukuda
DVD Handy Navigation System Prototype, 1996
Plastic
5 1/8 x 6 7/8 x 1 5/8 in. (13 x 17.5 x 4.1 cm)
Collection of the San Francisco Museum of Modern
 Art, Gift of Samsung Electronics Design Institute

Damian J. Kim
NETboard Prototype, 1996
Plastic and rubber
3 x 16 3/4 x 7 in. (7.6 x 42.6 x 17.8 cm)
Collection of the San Francisco Museum of Modern
 Art, Gift of Samsung Electronics Design Institute

REFERENCES

The following represents a complete list of references
for the excerpted texts that appear throughout the
essays. They are intended to provide critical
commentary on the issues raised by the exhibition
and to suggest avenues for further investigation.
An enormous debt of gratitude is owed to Julia Bryan-
Wilson, who compiled nearly all of the excerpts that
appear in this catalogue, on the *010101* Web site, and
in the exhibition galleries.

These texts are quoted within this publication in
accordance with the "fair use" doctrine of copyright law.
Those wishing to use them in any other context should
contact the publishers of the original materials directly.

Ant Farm. 1975. "Media Burn." In *Video Art: An
Anthology,* ed. Ira Schneider and Beryl Korot. New York:
Harcourt, Brace, Jovanovich, 1976. Page 11.

Ascott, Roy. 1989. "Gesamtdatenwerk: Connectivity,
Transformation, and Transcendence." In *Ars Electronica:
Facing the Future,* ed. Timothy Druckrey. Cambridge:
MIT Press, 1999. Page 86.

Barlow, John. 1990. "Being in Nothingness: Virtual
Reality and the Pioneers of Cyberspace." *Mondo 2000,*
no. 2 (summer): 41.

Baudrillard, Jean. 1983. "The Precession of Simulacra."
Art & Text, no. 11 (spring): 32.

Benjamin, Walter. 1936. "The Work of Art in the Age
of Mechanical Reproduction." In *Illuminations: Essays and
Reflections,* ed. Hannah Arendt and trans. Harry Zohn.
New York: Schocken Books, 1968. Page 234.

Boccioni, Umberto, et al. 1910. "Futurist Painting:
Technical Manifesto." In *Art in Theory, 1900–1990:
An Anthology of Changing Ideas,* ed. Charles Harrison and
Paul Wood. Oxford and Cambridge, Mass.: Blackwell,
1993. Page 150.

Brecht, Bertolt. [c. 1926.] "The Radio as an Apparatus
of Communication." In *Brecht on Theater: The Development
of an Aesthetic.* Ed. and trans. John Willett. New York:
Hill and Wang, 1964. Republished in *Video Culture: A
Critical Investigation,* ed. John G. Hanhardt. Layton, Utah:
G. M. Smith, Peregrine Smith Books, in association
with Visual Studies Workshop Press, 1986. Page 53.

Breton, André. 1924. "Manifesto of Surrealism." In
Manifestoes of Surrealism, trans. Richard Seaver and Helen
Lane. Ann Arbor, Mich.: Ann Arbor Paperbacks, 1972.
Page 46.

Butler, Samuel. 1872. "The Book of the Machine." In
Fairy Tales for Computers. New York: Eakins Press, 1969.
Page 121.

Campanella, Thomas J. 2000. "Eden by Wire:
Webcameras and the Telepresent Landscape." In *The
Robot in the Garden: Telerobotics and Telepistemology in the Age of
the Internet,* ed. Ken Goldberg. Cambridge: MIT Press.
Page 23.

Carlyle, Thomas. 1829. "Signs of the Times." *Edinburgh Review.* Cited in *The Machine in the Garden: Technology and the Pastoral Ideal in America,* by Leo Marx. New York: Oxford University Press, 1964. Page 170.

Certeau, Michel de. 1984. *The Practice of Everyday Life,* trans. Steven Rendall. Berkeley: University of California Press. Page xxi.

Crary, Jonathan. 1984. "Eclipse of the Spectacle." In *Art after Modernism: Rethinking Representation,* ed. Brian Wallis. New York: New Museum of Contemporary Art. Page 291.

Davis, Douglas. 1976. "Interview with Douglas Davis by David Ross." In *Video Art: An Anthology,* ed. Ira Schneider and Beryl Korot. New York: Harcourt, Brace, Jovanovich. Page 33.

Debord, Guy. 1967. *The Society of the Spectacle,* trans. Donald Nicholson-Smith. New York: Zone Books, 1994. Page 12.

DeLillo, Don. 1985. *White Noise.* New York: Penguin. Page 36.

Drew, Jesse. 1995. "Media Activism and Radical Democracy." In *Resisting the Virtual Life: The Culture and Politics of Information,* ed. James Brook and Iain A. Boal. San Francisco: City Lights. Page 83.

Druckrey, Timothy. 1994. "Introduction." In *Culture on the Brink: Ideologies of Technology,* ed. Gretchen Bender and Timothy Druckrey. Seattle: Bay Press. Page 2.

DuBois, W. E. B. 1945. *Chicago Defender.* Cited in *By the Bomb's Early Light: American Thought and Culture at the Dawn of the Atomic Age,* by Paul Boyer. New York: Pantheon, 1985. Page 269.

Dyson, Frances. 1998. "'Space,' 'Being,' and Other Fictions in the Domain of the Virtual." In *The Virtual Dimension: Architecture, Representation, and Crash Culture,* ed. John Beckmann. New York: Princeton Architectural Press. Page 42.

Enzensberger, Hans Magnus. 1974. "Constituents of a Theory of the Media." In *The Consciousness Industry,* trans. Stuart Hood. New York: Seabury Press. Republished in *Video Culture: A Critical Investigation,* ed. John G. Hanhardt. Layton, Utah: G. M. Smith, Peregrine Smith Books, in association with Visual Studies Workshop Press, 1986. Page 104.

Fuller, R. Buckminster. 1970. Cited in *Expanded Cinema,* by Gene Youngblood. New York: E. P. Dutton. Page 46.

Gibson, William. 1984. *Neuromancer,* New York: Ace. Page 5.

Harvey, David. 1990. *The Condition of Postmodernity.* Oxford and Cambridge, Mass.: Blackwell. Page 44.

Hayles, N. Katherine. 1999. "The Condition of Virtuality." In *The Digital Dialectic: New Essays on New Media,* ed. Peter Lunenfeld. Cambridge: MIT Press. Page 69.

Holtzman, Steven R. 1994. *Digital Mantras: The Languages of Abstract and Virtual Worlds.* Cambridge: MIT Press. Pages 220, 221.

Johnson, Steven. 1997. *Interface Culture: How New Technology Transforms the Way We Create and Communicate.* San Francisco: Basic Books. Page 213.

Kelly, Kevin. 1992. *Out of Control: The New Biology of Machines, Social Systems, and the Economic World.* Reading, Mass.: Addison-Wesley. Page 440.

Klüver, Billy. 1967. "Theater and Engineering—An Experiment: Notes by an Engineer." In *Theories and Documents of Contemporary Art: A Sourcebook of Artists' Writings,* ed. Kristine Stiles and Peter Selz. Berkeley: University of California Press, 1996. Page 412.

Meyrowitz, Joshua. 1985. *No Sense of Place: The Impact of Electronic Media on Social Behavior.* New York: Oxford University Press. Page vii.

Mitchell, William J. 1995. *City of Bits: Space, Place, and the Infobahn.* Cambridge: MIT Press. Page 30.

Negroponte, Nicholas. 1995. *Being Digital.* New York: Knopf. Page 4.

Operation Atomic Vision. 1948. A teaching unit for high school students, prepared by Hubert M. Evans, Ryland W. Crary, and C. Glen Hass for the National Association of Secondary-School Principals. Washington, D.C.: U.S. Atomic Energy Commission. Pages 5–7.

Pollock, Jackson. 1950. "Interview with William Wright." In *Theories and Documents of Contemporary Art: A Sourcebook of Artists' Writings.* Ed. Kristine Stiles and Peter Selz. Berkeley: University of California Press, 1996. Page 22.

Pynchon, Thomas. 1966. *The Crying of Lot 49.* New York: J. B. Lippincott. Reprint, New York: Harper and Row, 1986. Page 181.

Rushkoff, Douglas. 1994. "Introduction." In *Cyberia: Life in the Trenches of Hyperspace.* San Francisco: Harper San Francisco.

Sherman, Tom. 1997. "Blanking," at www.allquiet.org/texts/archive/blanking.shtml.

——. 1999. "T NOT P." From "Millennial Spurn." Nettime, Thingist, and Rhizome Raw listserves.

Shields, David. 1996. *Remote.* New York: Knopf. Page 12.

Simmel, Georg. 1902. "The Metropolis and Mental Life." In *The Sociology of Georg Simmel,* ed. and trans. Kurt Wolff. Glencoe, Ill.: Free Press, 1950. Republished in *Art in Theory, 1900–1990: An Anthology of Changing Ideas,* ed. Charles Harrison and Paul Wood. Oxford and Cambridge, Mass.: Blackwell, 1993. Page 131.

Ullman, Ellen. 1997. *Close to the Machine: Technophilia and Its Discontents.* San Francisco: City Lights Books. Page 32.